THE METROPOLITAN MUSEUM OF ART

Christmas Is Coming!

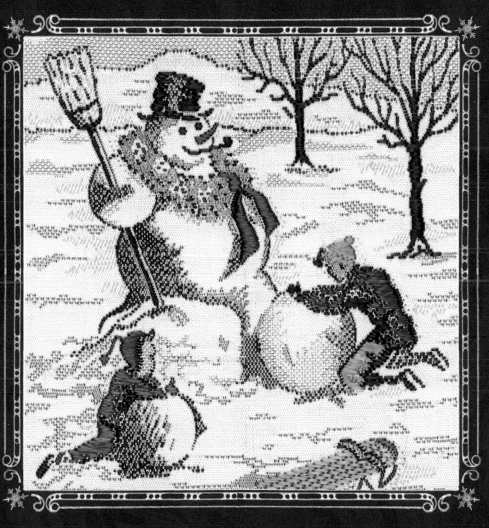

Celebrate the Holiday with Art, Stories, Poems, Songs, and Recipes

Abrams Books for Young Readers · New York

Note: A few of the stories herein begin with an explanatory note to reveal points of interest. The poets of the specially commissioned poems have also provided a few sentences about their work.

Title page
Holiday ribbon featuring scene of snowman,
1960–82, Warner Woven Label Co.

Opposite
Christmas Card Depicting Hanging Holly by Candlelight,
ca. 1920s, Anonymous

Contents page
Deer in the Woods,
1850, Charles-François Daubigny

Throughout
Snow Crystal images by Wilson Alwyn Bentley.
For full information, see page 157.

Cataloging-in-Publication Data has been applied for and may be obtained from the Library of Congress.

ISBN 978-1-4197-3749-7

Credits for original poems and recipes can be found on page 155.

Edited by Howard W. Reeves
Book design by John Passineau

Printed and bound in China

10 9 8 7 6 5 4 3 2 1

Abrams Books for Young Readers are available at special discounts when purchased in quantity for premiums and promotions as well as fundraising or educational use. Special editions can also be created to specification. For details, contact specialsales@abramsbooks.com or the address below.

Abrams® is a registered trademark of Harry N. Abrams, Inc.

ABRAMS The Art of Books
195 Broadway, New York, NY 10007
abramsbooks.com

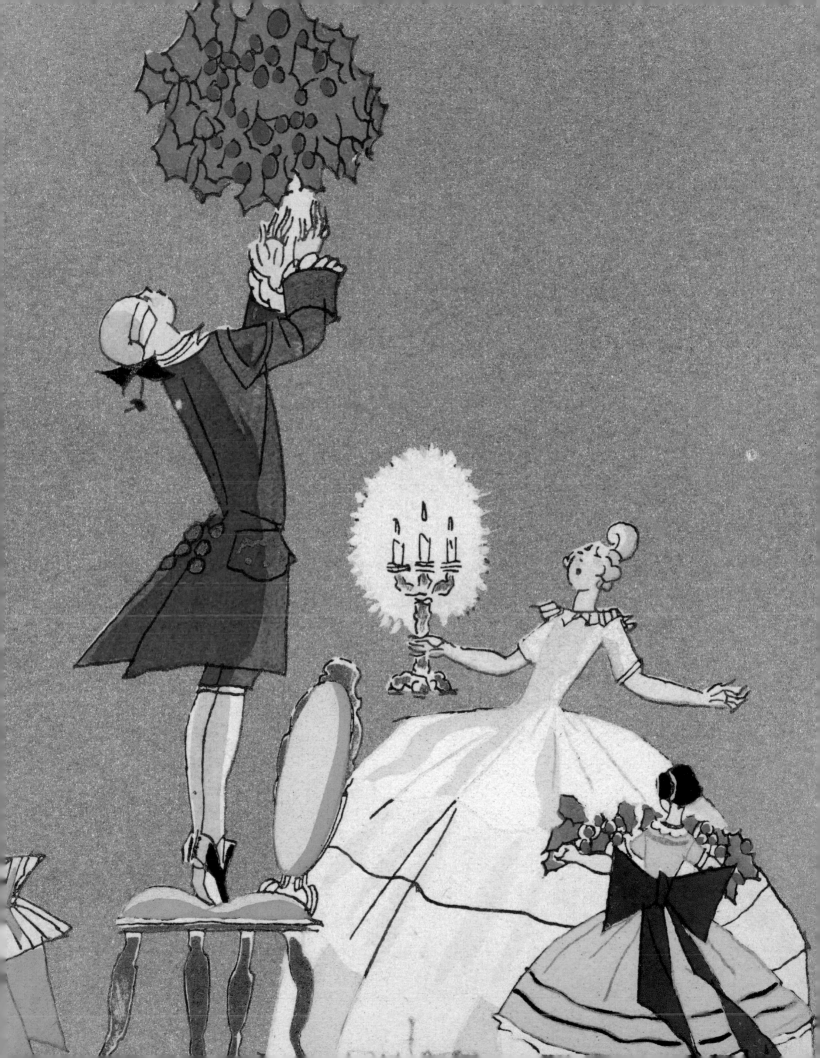

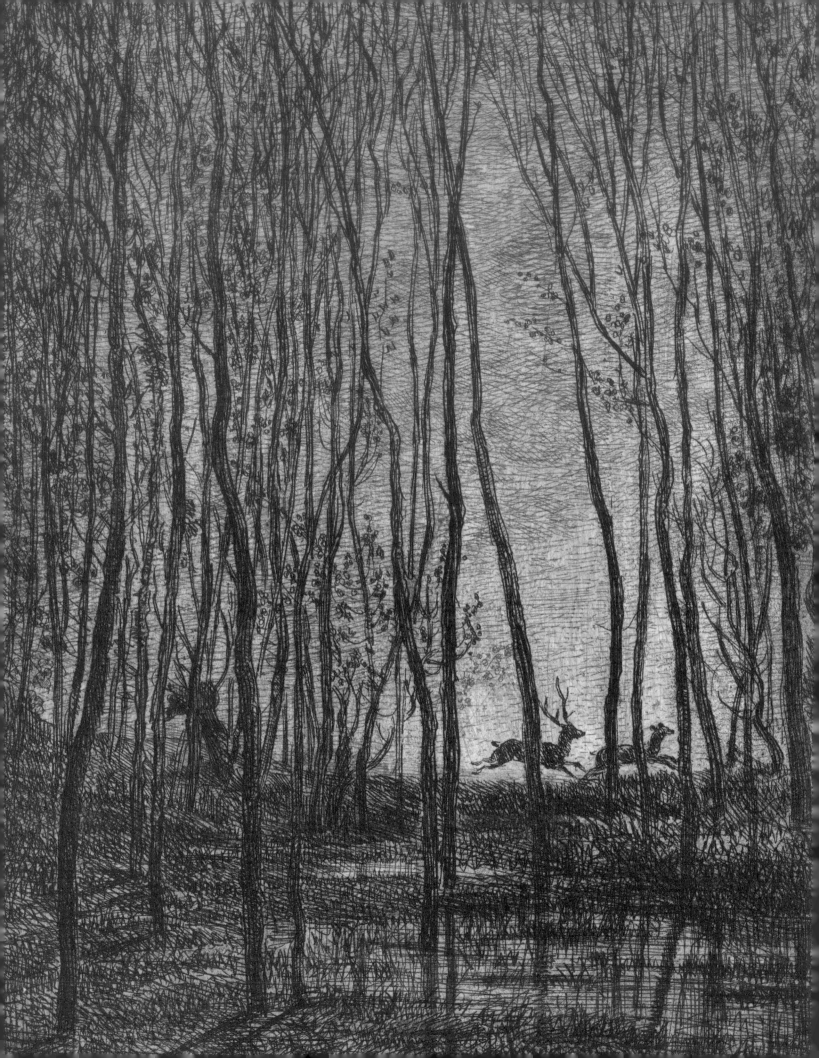

CONTENTS

PART ONE
The First Christmas

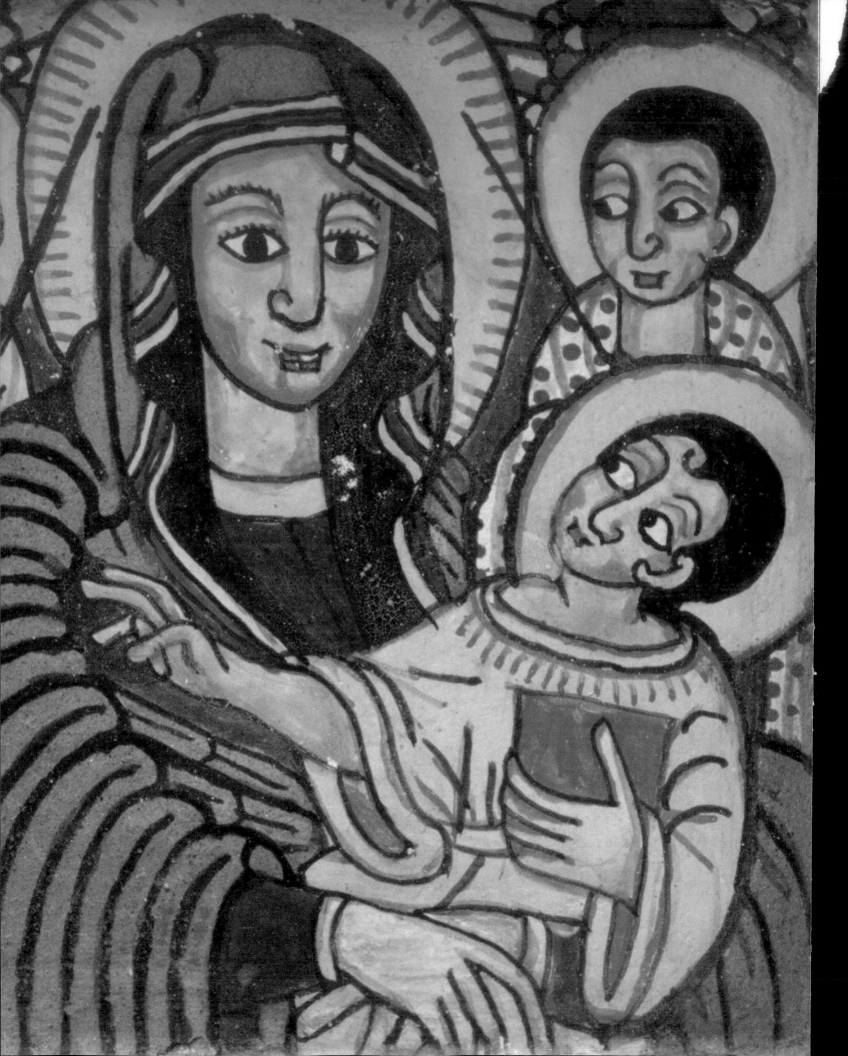

THE CHRISTMAS STORY

(THIS VERSION IS TAKEN FROM LUKE 1:26–38 AND 2:1–16.)

The angel Gabriel was sent from God unto a city of Galilee, named Nazareth, to a virgin engaged to a man whose name was Joseph, of the house of David; and the virgin's name was Mary.

And the angel said, "Hail, thou that art highly favored, the Lord is with thee. Blessed art thou among women."

When Mary saw him, she was troubled at his words and wondered what manner of greeting this could be. And the angel said unto her, "Fear not, Mary, for you have found favor with God. And, behold, you shall conceive in your womb and bring forth a son, and shall call his name Jesus. He shall be great and shall be called the Son of the Highest; and the Lord God shall give unto him the throne of his father David. And he shall reign over the house of Jacob forever, and of his kingdom there shall be no end."

Then said Mary to the angel, "How shall this be, seeing I know not a man?"

The angel answered, "The Holy Ghost shall come upon you, and the power of the Highest shall overshadow you. Therefore, that holy child who shall be born of you shall be called the Son of God."

Mary said, "Behold the handmaid of the Lord; be it unto me according to your word." And the angel departed from her.

And it came to pass in those days that there went out a decree from Caesar Augustus that all the world should be taxed.

(And this taxing was first made when Quirinius was governor of Syria.)

And all went to be taxed, everyone into his own city.

Double Diptych Icon Pendant (detail)
Ethiopia, early eighteenth century

And Joseph also went up from Galilee, out of the city of Nazareth into Judaea unto the city of David, which is called Bethlehem (because he was of the house and lineage of David) to be taxed with Mary his espoused wife, being great with child.

And so it was that, while they were there, the days were accomplished that she should be delivered.

And she brought forth her firstborn son, wrapped him in swaddling clothes, and laid him in a manger, because there was no room for them in the inn.

And in the same country were shepherds abiding in the field, keeping watch over their flock by night.

And, lo, the angel of the Lord came upon them, and the glory of the Lord shone round about them, and they were so afraid.

And the angel said unto them, "Fear not, for, behold, I bring you good tidings of great joy, which shall be to all people.

"For unto you is born this day in the city of David a Savior, who is Christ the Lord.

"And this shall be a sign unto you: Ye shall find the babe wrapped in swaddling clothes, lying in a manger."

And suddenly, with the angel appeared a multitude of the heavenly host praising God and saying,

"Glory to God in the highest, and on earth peace and good will toward men."

And it came to pass, as the angels were gone away from them into heaven, the shepherds said one to another, "Let us now go even unto Bethlehem and see this thing which is come to pass, which the Lord hath made known unto us."

And they came with haste and found Mary and Joseph, and the babe lying in a manger.

The Adoration of the Shepherds (detail)
1374, Bartolo di Fredi

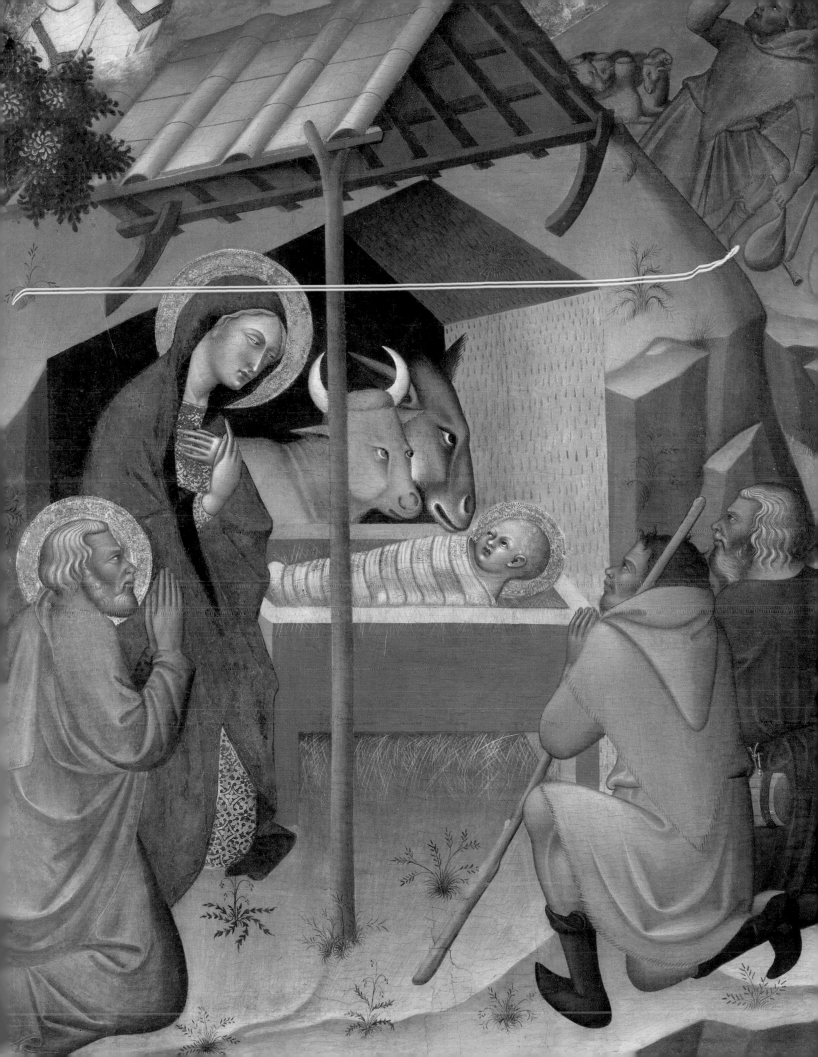

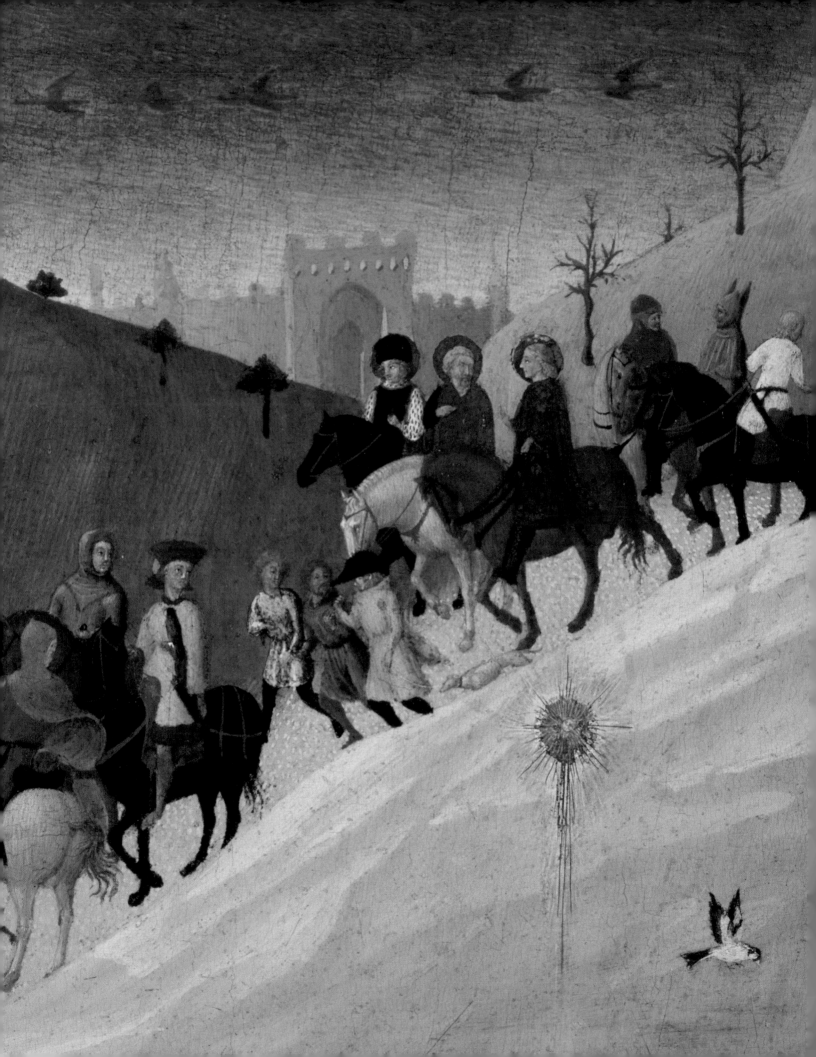

The Three Wise Men

(THIS VERSION IS TAKEN FROM MATTHEW 2:1–14.)

Now when Jesus was born in Bethlehem of Judaea in the days of Herod the king, behold, there came wise men from the east to Jerusalem.

Saying, "Where is he that is born King of the Jews? For we have seen his star in the east and are come to worship him."

When Herod the king had heard these things, he was troubled, and all Jerusalem with him.

And when he had gathered all the chief priests and scribes of the people together, he demanded of them where Christ should be born.

And they said unto him, "In Bethlehem of Judaea, for thus it is written by the prophet.

"And thou Bethlehem, in the land of Judaea, art not the least among the princes of Judah; for out of thee shall come a Governor, that shall rule my people Israel."

Then Herod, when he had privily called the wise men, enquired of them diligently what time the star appeared.

And he sent them to Bethlehem, saying, "Go and search diligently for the young child. And when ye have found him, bring me word again, that I may come and worship him also."

The Journey of the Magi (detail)
ca. 1433–35, Sassetta (Stefano di Giovanni)

When they had heard the king, they departed; and, lo, the star, which they saw in the east, went before them till it came and stood over where the young child was.

When they saw the star, they rejoiced with exceedingly great joy.

When they were come into the house, they saw the young child with Mary his mother and fell down and worshipped him. And when they had opened their treasures, they presented unto him gifts of gold and frankincense and myrrh.

Being warned of God in a dream that they should not return to Herod, they departed into their own country another way.

And when they were departed, behold, the angel of the Lord appeared to Joseph in a dream, saying, "Arise, and take the young child and his mother and flee into Egypt, and be thou there until I bring thee word: for Herod will seek the young child to destroy him."

When he arose, Joseph took the young child and his mother by night and departed into Egypt.

Flight Into Egypt
1923, Henry Ossawa Tanner

A Russian Church in Snow with a Man Riding a Sleigh
Twentieth century, Sergei Lednev-Shchukin

PART TWO
Stories and Tales

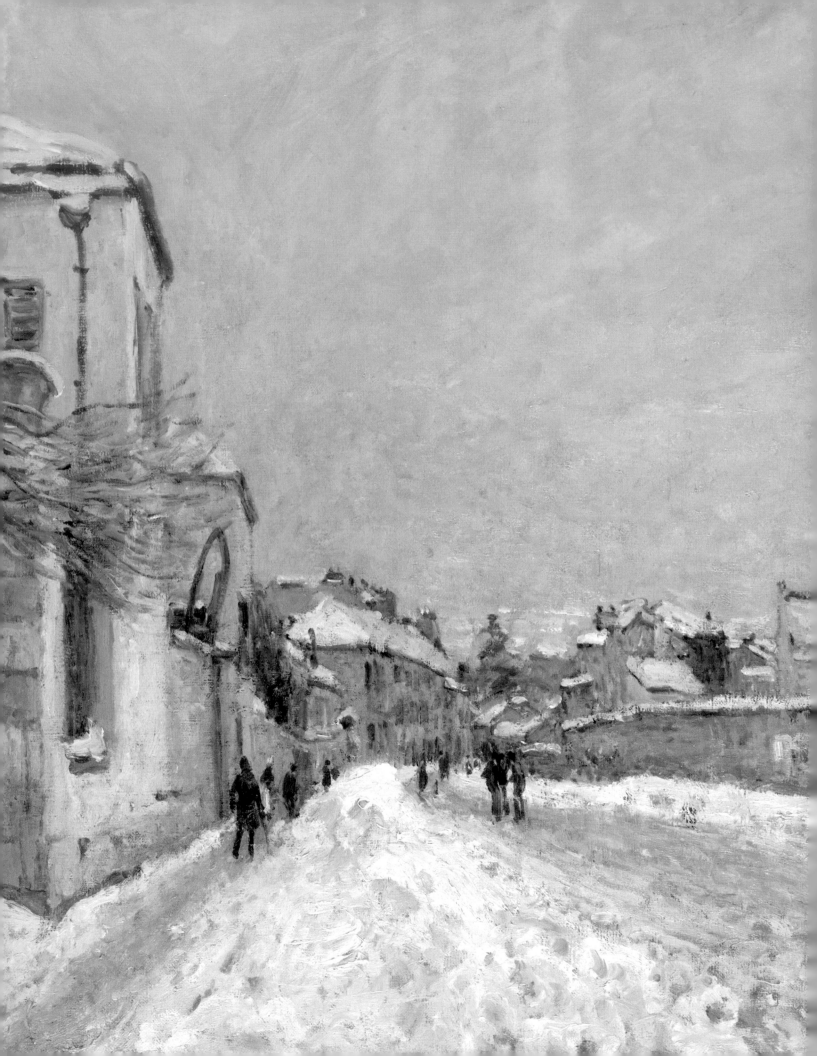

Papa Panov's Special Christmas

Translated into English by Leo Tolstoy

It was Christmas Eve and although it was still afternoon, lights had begun to appear in the shops and houses of the little Russian village, for the short winter day was nearly over. Excited children scurried indoors, and now only muffled sounds of chatter and laughter escaped from closed shutters.

Old Papa Panov, the village shoemaker, stepped outside his shop to take one last look around. The sounds of happiness, the bright lights, and the faint but delicious smells of Christmas cooking reminded him of past Christmas times when his wife had still been alive and his own children little. Now they had gone. His usually cheerful face, with the little laughter wrinkles behind the round steel spectacles, looked sad now. But he went back indoors with a firm step, put up the shutters, and set a pot of coffee to heat on the charcoal stove. Then, with a sigh, he settled in his big armchair.

Papa Panov did not often read, but tonight he pulled down the big old family Bible and, slowly tracing the lines with one forefinger, he read again the Christmas story. He read how Mary and Joseph, tired by their journey to Bethlehem, found no room for them at the inn, so that Mary's little baby was born in the cowshed.

"Oh, dear, oh, dear!" exclaimed Papa Panov, "if only they had come here! I would have given them my bed and I could have covered the baby with my patchwork quilt to keep him warm."

He read on about the wise men who had come to see the baby Jesus, bringing him splendid gifts. Papa Panov's face fell. "I have no gift that I could give him," he thought sadly.

Then his face brightened. He put down the Bible, got up and stretched his long arms to the shelf high up in his little room. He took down a small, dusty box and opened it. Inside was a perfect pair of tiny leather shoes. Papa Panov smiled with satisfaction. Yes, they were as good as he had remembered—the best shoes he had ever made. "I should give him those," he decided, as he gently put them away and sat down again.

Shoes
1840–49

Rue Eugène Moussoir at Moret: Winter (detail)
1891, Alfred Sisley

He was feeling tired now, and the further he read, the sleepier he became. The print began to dance before his eyes so he closed them, just for a minute. In no time at all, Papa Panov was fast asleep.

And as he slept, he dreamed. He dreamed that someone was in his room, and he knew at once, as one does in dreams, who the person was. It was Jesus.

"You have been wishing that you could see me, Papa Panov," he said kindly, "then look for me tomorrow. It will be Christmas Day, and I will visit you. But look carefully, for I shall not tell you who I am."

When at last Papa Panov awoke, the bells were ringing out, and a thin light was filtering through the shutters. "Bless my soul!" said Papa Panov. "It's Christmas Day!"

He stood up and stretched himself for he was rather stiff. Then his face filled with happiness as he remembered his dream. This would be a very special Christmas after all, for Jesus was coming to visit him. How would he look? Would he be a little baby, as at that first Christmas? Would he be a grown man, a carpenter—or the great King that he is, God's Son? He must watch carefully the whole day through, so that he recognized him however he came.

Papa Panov put on a special pot of coffee for his Christmas breakfast, took down the shutters, and looked out of the window. The street was deserted, no one was stirring yet. No one except the road sweeper. He looked as miserable and dirty as ever, and well he might! Whoever wanted to work on Christmas Day—and in the raw cold and bitter freezing mist of such a morning?

Papa Panov opened the shop door, letting in a thin stream of cold air. "Come in!" he shouted across the street cheerily. "Come in and have some hot coffee to keep out the cold!"

The sweeper looked up, scarcely able to believe his ears. He was only too glad to put down his broom and come into the warm room. His old clothes steamed gently in the heat of the stove, and he clasped both red hands round the comforting warm mug as he drank.

Papa Panov watched him with satisfaction, but every now and then his eyes strayed to the window. It would never do to miss his special visitor.

"Expecting someone?" the sweeper asked at last. So Papa Panov told him about his dream.

"Well, I hope he comes," the sweeper said, "You've given me a bit of Christmas cheer I never expected to have. I'd say you deserve to have your dream come true." And he actually smiled.

When he had gone, Papa Panov put on cabbage soup for his dinner, then went to the door again, scanning the street. He saw no one. But he was mistaken. Someone was coming.

The girl walked so slowly and quietly, hugging the walls of shops and houses, that it was a while before he noticed her. She looked very tired and she was carrying something. As she drew nearer he could see that it was a baby, wrapped in a thin shawl. There was such sadness in her face and in the pinched little face of the baby that Papa Panov's heart went out to them.

"Won't you come in," he called, stepping outside to meet them. "You both need a warm by the fire and a rest." The young mother let him shepherd her indoors and to the comfort of the armchair. She gave a big sigh of relief.

"I'll warm some milk for the baby," Papa Panov said. "I've had children of my own—I can feed her for you." He took the milk from the stove and carefully fed the baby from a spoon, warming her tiny feet by the stove at the same time.

"She needs shoes," the cobbler said.

But the girl replied, "I can't afford shoes, I've got no husband to bring home money. I'm on my way to the next village to get work."

A sudden thought flashed through Papa Panov's mind. He remembered the little shoes

he had looked at last night. But he had been keeping those for Jesus. He looked again at the cold little feet and made up his mind.

"Try these on her," he said, handing the baby shoes to the mother. The beautiful little shoes were a perfect fit. The girl smiled happily, and the baby gurgled with pleasure.

"You have been so kind to us," the girl said, when she got up with her baby to go. "May all your Christmas wishes come true!"

But Papa Panov was beginning to wonder if his very special Christmas wish would come true. Perhaps he had missed his visitor? He looked anxiously up and down the street. There were plenty of people about but they were all faces that he recognized. There were neighbors going to call on their families. They nodded and smiled and wished him Happy Christmas! Or there were beggars—and Papa Panov hurried indoors to fetch them hot soup and a generous hunk of bread, hurrying out again in case he missed the Important Stranger.

All too soon the winter dusk fell. When Papa Panov next went to the door and strained his eyes, he could no longer make out the passersby. Most were home and indoors by now anyway. He walked slowly back into his room at last, put up the shutters, and sat down wearily in his armchair.

So it had been just a dream after all. Jesus had not come.

Then all at once he knew that he was no longer alone in the room.

This was not dream for he was wide-awake. At first he seemed to see before his eyes the long stream of people who had come to him that day. He saw again the old road sweeper, the young mother and her baby, and the beggars he had fed. As they passed, each whispered, "Didn't you see me, Papa Panov?"

"Who are you?" he called out, bewildered.

Then another voice answered him. It was the voice from his dream—the voice of Jesus.

"I was hungry and you fed me," he said. "I was naked and you clothed me. I was cold and you warmed me. I came to you today in everyone of those you helped and welcomed."

Then all was quiet and still. Only the sound of the big clock ticking. A great peace and happiness seemed to fill the room, overflowing Papa Panov's heart until he wanted to burst out singing and laughing and dancing with joy.

"So he did come after all!" was all that he said.

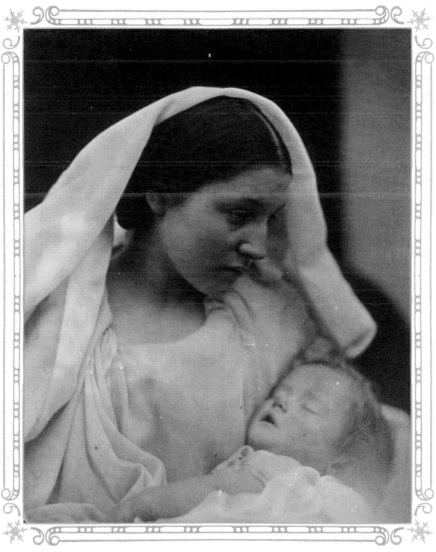

La Madonna Riposata
1865, Julia Margaret Cameron

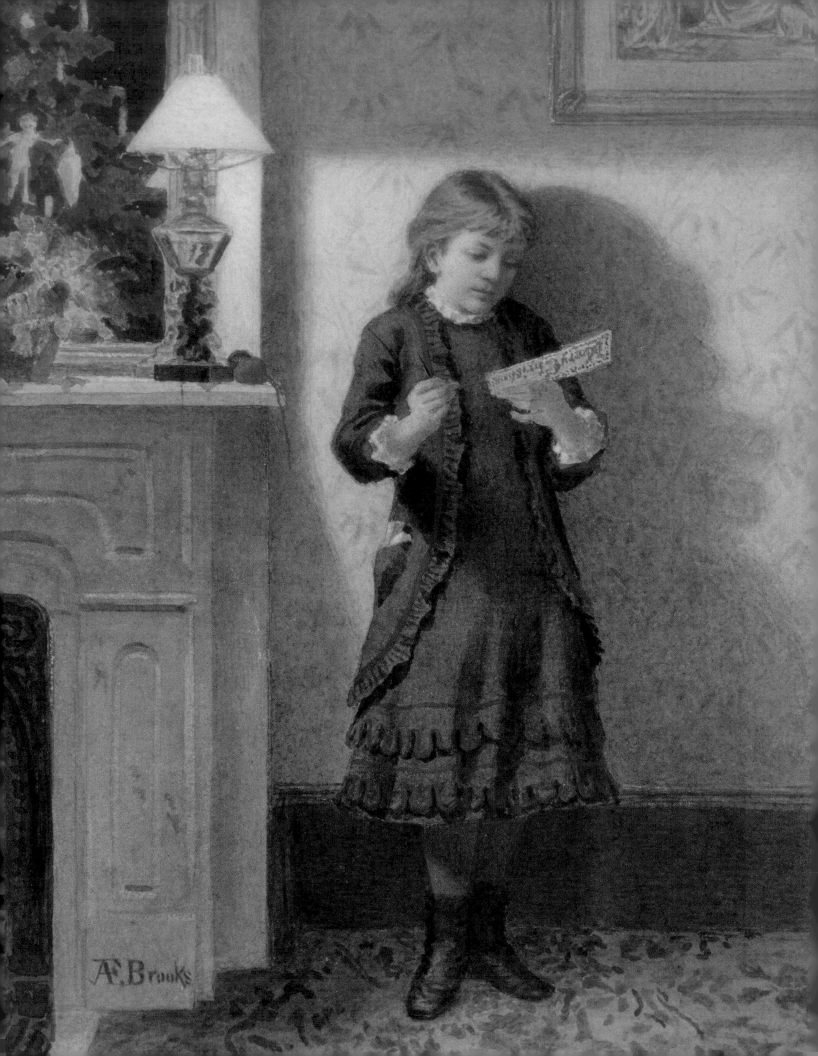

Yes, Virginia, There Is a Santa Claus

By Francis Pharcellus Church

In 1897 Virginia O'Hanlon, the eight-year-old daughter of Dr. Philip O'Hanlon, asked whether Santa Claus truly existed. O'Hanlon suggested she write to the *Sun*, a New York City newspaper at the time, assuring her that "If you see it in the *Sun*, it's so." Francis Pharcellus Church, an editor at the paper took on the challenge. "Yes, Virginia, there is a Santa Claus" is a phrase from his editorial called "Is There a Santa Claus?" It appeared in the September 21, 1897, edition of the *New York Sun*.

We take pleasure in answering at once and thus prominently the communication below, expressing at the same time our great gratification that its faithful author is numbered among the friends of THE SUN:

> *Dear Editor:*
> *I am 8 years old.*
> *Some of my little friends say there is no Santa Claus.*
> *Papa says, "If you see it in The Sun, it's so."*
> *Please tell me the truth, is there a Santa Claus?*
> *Virginia O'Hanlon*
> *115 West Ninety-Fifth Street*

VIRGINIA, your little friends are wrong. They have been affected by the skepticism of a skeptical age. They do not believe except they see. They think that nothing can be which is not comprehensible by their little minds. All minds, VIRGINIA, whether they be men's or children's, are little. In this great universe of ours man is a mere insect, an ant, in his intellect, as compared with the boundless world about him, as measured by the intelligence capable of grasping the whole of truth and knowledge.

Yes, VIRGINIA, there is a Santa Claus. He exists as certainly as love and generosity and devotion exist, and you know that they abound and give to your life its highest beauty and joy. Alas! how dreary would be the world if there were no Santa Claus. It would be as dreary as if there were no VIRGINIAS. There would be no childlike faith then, no poetry, no romance to make tolerable this existence. We should have no enjoyment

Child with Christmas Card
n.d., Alden Finney Brooks

except in sense and sight. The eternal light with which childhood fills the world would be extinguished.

Not believe in Santa Claus! You might as well not believe in fairies! You might get your papa to hire men to watch in all the chimneys on Christmas Eve to catch Santa Claus, but even if they did not see Santa Claus coming down, what would that prove? Nobody sees Santa Claus, but that is no sign that there is no Santa Claus. The most real things in the world are those that neither children nor men can see. Did you ever see fairies dancing on the lawn? Of course not, but that's no proof that they are not there. Nobody can conceive or imagine all the wonders there are unseen and unseeable in the world.

You may tear apart the baby's rattle and see what makes the noise inside, but there is a veil covering the unseen world, which not the strongest man, nor even the united strength of all the strongest men that ever lived, could tear apart. Only faith, fancy, poetry, love, romance can push aside that curtain and view and picture the supernal beauty and glory beyond. Is it all real? Ah, VIRGINIA, in all this world there is nothing else real and abiding.

No Santa Claus! Thank God! he lives, and he lives forever. A thousand years from now, VIRGINIA, nay, ten times ten thousand years from now, he will continue to make glad the heart of childhood.

The Adventure of the Blue Carbuncle

By Sir Arthur Conan Doyle

I had called upon my friend Sherlock Holmes upon the second morning after Christmas with the intention of wishing him the compliments of the season. He was lounging upon the sofa in a purple dressing gown, a pipe rack within his reach upon the right, and a pile of crumpled morning papers, evidently newly studied, near at hand. Beside the couch was a wooden chair, and on the angle of the back hung a very seedy and disreputable hard felt hat, much the worse for wear, and cracked in several places. A lens and a forceps lying upon the seat of the chair suggested that the hat had been suspended in this manner for the purpose of examination.

"You are engaged," said I. "Perhaps I interrupt you."

"Not at all. I am glad to have a friend with whom I can discuss my results. The matter is a perfectly trivial one"—he jerked his thumb in the direction of the old hat—"but there are points in connection with it that are not entirely devoid of interest and even of instruction."

I seated myself in his armchair and warmed my hands before his crackling fire, for a sharp frost had set in, and the windows were thick with the ice crystals. "I suppose," I remarked, "that, homely as it looks, this thing has some deadly story linked onto it—that it is the clue that will guide you in the solution of some mystery and the punishment of some crime."

"No, no. No crime," said Sherlock Holmes, laughing. "Only one of those whimsical little incidents that will happen when you have four-million human beings all jostling each other within the space of a few square miles. Amid the action and reaction of so dense a swarm of humanity, every possible combination of events may be expected to take place, and many a little problem will be presented that may be striking and bizarre without being criminal. We have already had experience of such."

"So much so," I remarked, "that of the last six cases that I have added to my notes, three have been entirely free of any legal crime."

"Precisely. You allude to my attempt to recover the Irene Adler papers, to the singular case of Miss Mary Sutherland, and to the adventure of the man with the twisted lip. Well, I have no doubt that this small matter will fall into the same innocent category. You know Peterson, the commissionaire?"

"Yes."

"It is to him that this trophy belongs."

"It is his hat."

"No, no, he found it. Its owner is unknown. I beg that you will look upon it not as a battered billycock but as an intellectual problem. And, first, as to how it came here: It arrived upon Christmas morning, in company with a good fat goose, which is, I have no doubt, roasting at this moment in front of Peterson's fire. The facts are these: about four o'clock on Christmas morning, Peterson, who, as you know, is a very honest fellow, was returning from some small jollification and was making his way homeward down Tottenham Court Road. In front of him he saw in the gaslight a tallish man walking with a slight stagger and carrying a white goose slung over his shoulder. As he reached the corner of Goodge Street, a row broke out between this stranger and a little knot of roughs. One of the latter knocked off the man's hat, on which he raised his stick to defend himself and, swinging it over his head, smashed the shop window behind him. Peterson had rushed forward to protect the stranger from his assailants; but the man, shocked at having broken the window and seeing an official-looking person in uniform rushing toward him, dropped his goose, took to his heels, and vanished amid the labyrinth of small streets that lie at the back of Tottenham Court Road. The roughs had also fled at the appearance of Peterson, so that he was left in possession of the field of battle and also of the spoils of victory in the shape of this battered hat and a most unimpeachable Christmas goose."

"Which surely he restored to their owner?"

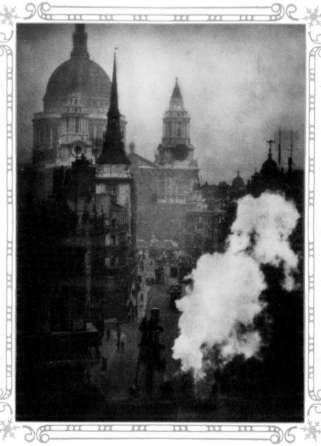

St. Paul's from the Ludgate Circus
1909, Alvin Langdon Coburn

"My dear fellow, there lies the problem. It is true that 'For Mrs. Henry Baker' was printed upon a small card that was tied to the bird's left leg, and it is also true that the initials 'H. B.' are legible upon the lining of this hat. But as there are some thousands of Bakers and some hundreds of Henry Bakers in this city of ours, it is not easy to restore lost property to any one of them."

"What, then, did Peterson do?"

"He brought round both hat and goose to me on Christmas morning, knowing that even the smallest problems are of interest to me. The goose we retained until this morning, when there were signs that, in spite of the slight frost, it would be well that it should be eaten without unnecessary delay. Its finder has carried it off, therefore, to fulfill the ultimate destiny of a goose, while I continue to retain the hat of the unknown gentleman who lost his Christmas dinner."

"Did he not advertise?"

"No."

"Then what clue could you have as to his identity?"

"Only as much as we can deduce."

"From his hat?"

"Precisely."

"But you are joking. What can you gather from this old battered felt?"

"Here is my lens. You know my methods. What can you gather yourself as to the individuality of the man who has worn this article?"

I took the tattered object in my hands and turned it over rather ruefully. It was a very ordinary black hat of the usual round shape, hard, and much the worse for wear. The lining had been of red silk,

but was a good deal discolored. There was no maker's name; but, as Holmes had remarked, the initials "H. B." were scrawled upon one side. It was pierced in the brim for a hat securer, but the elastic was missing. For the rest, it was cracked, exceedingly dusty, and spotted in several places, although there seemed to have been some attempt to hide the discolored patches by smearing them with ink.

"I can see nothing," said I, handing it back to my friend.

"On the contrary, Watson, you can see everything. You fail, however, to reason from what you see. You are too timid in drawing your inferences."

"Then pray tell me what it is that you can infer from this hat?"

He picked it up and gazed at it in the peculiar introspective fashion that was characteristic of him. "It is perhaps less suggestive than it might have been," he remarked, "and yet there are a few inferences that are very distinct and a few others that represent at least a strong balance of probability. That the man was highly intellectual is of course obvious upon the face of it, and also that he was fairly well-to-do within the last three years, although he has now fallen upon evil days. He had foresight but has less now than formerly, pointing to a moral retrogression, which, when taken with the decline of his fortunes, seems to indicate some evil influence—probably drink—at work upon him. This may account also for the obvious fact that his wife has ceased to love him."

"My dear Holmes!"

"He has, however, retained some degree of self-respect," he continued, disregarding my remonstrance. "He is a man who leads a sedentary life, goes out little, is out of training entirely, is middle-aged, has grizzled hair, which he has had cut within the last few days and which he anoints with lime cream. These are the more patent facts that are to be deduced from his hat. Also, by the way, that it is extremely improbable that he has gas laid on in his house."

"You are certainly joking, Holmes."

"Not in the least. Is it possible that even now, when I give you these results, you are unable to see how they are attained?"

"I have no doubt that I am very stupid, but I must confess that I am unable to follow you. For example, how did you deduce that this man was intellectual?"

For answer Holmes clapped the hat upon his head. It came right over the forehead and settled upon the bridge of his nose. "It is a question of cubic capacity," said he. "A man with so large a brain must have something in it."

"The decline of his fortunes then?"

"This hat is three years old. These flat brims curled at the edge came in then. It is a hat of the very best quality. Look at the band of ribbed silk and the excellent lining. If this man could afford to buy so expensive a hat three years ago and has had no hat since, then he has assuredly gone down in the world."

"Well, that is clear enough certainly. But how about the foresight and the moral retrogression?"

Sherlock Holmes laughed. "Here is the foresight," said he putting his finger upon the little disc and loop of the hat securer. "They are never sold upon hats. If this man ordered one, it is a sign of a certain amount of foresight, since he went out of his way to take this precaution against the wind. But since we see that he has broken the elastic and has not troubled to replace it, it is obvious that he has less foresight now than formerly, which is a distinct proof of a weakening nature. On the other hand, he has endeavored to conceal some of these stains upon the felt by daubing them with ink, which is a sign that he has not entirely lost his self-respect."

"Your reasoning is certainly plausible."

"The further points—that he is middle-aged, that his hair is grizzled, that it has been recently cut, and that he uses lime cream—are all to be gathered from a close examination of the lower part of the lining. The lens discloses a large number of hair ends, clean cut by the scissors of the barber. They all appear to be adhesive, and there is a distinct odor of lime cream. This dust, you will observe, is not the gritty, gray dust of the street but the fluffy brown dust of the house, showing that it has been hung up indoors most of the time, while the marks of moisture upon the

inside are proof positive that the wearer perspired very freely and could, therefore, hardly be in the best of training."

"But his wife—you said that she had ceased to love him."

"This hat has not been brushed for weeks. When I see you, my dear Watson, with a week's accumulation of dust upon your hat, and when your wife allows you to go out in such a state, I shall fear that you also have been unfortunate enough to lose your wife's affection."

"But he might be a bachelor."

"Nay, he was bringing home the goose as a peace offering to his wife. Remember the card upon the bird's leg."

"You have an answer to everything. But how on earth do you deduce that the gas is not laid on in his house?"

"One tallow stain, or even two, might come by chance; but when I see no less than five, I think that there can be little doubt that the individual must be brought into frequent contact with burning tallow—walks upstairs at night probably with his hat in one hand and a guttering candle in the other. Anyhow, he never got tallow stains from a gas jet. Are you satisfied?"

"Well, it is very ingenious," said I, laughing, "but since, as you said just now, there has been no crime committed and no harm done save the loss of a goose, all this seems to be rather a waste of energy."

Sherlock Holmes had opened his mouth to reply when the door flew open, and Peterson, the commissionaire, rushed into the apartment with flushed cheeks and the face of a man who is dazed with astonishment.

"The goose, Mr. Holmes! The goose, sir!" he gasped.

"Eh? What of it then? Has it returned to life and flapped off through the kitchen window?" Holmes twisted himself round upon the sofa to get a fairer view of the man's excited face.

"See here, sir! See what my wife found in its crop!" He held out his hand and displayed upon the center of the palm a brilliantly scintillating blue stone, rather smaller than a bean in size but of such purity and radiance that it twinkled like an electric point in the dark hollow of his hand.

Sherlock Holmes sat up with a whistle. "By Jove, Peterson!" said he, "this is a treasure trove indeed. I suppose you know what you have got?"

"A diamond, sir? A precious stone. It cuts into glass as though it were putty."

"It's more than a precious stone. It is *the* precious stone."

"Not the Countess of Morcar's blue carbuncle!" I ejaculated.

"Precisely so. I ought to know its size and shape, seeing that I have read the advertisement about it in the *Times* every day lately. It is absolutely unique, and its value can only be conjectured, but the reward offered of a thousand pounds is certainly not within a twentieth part of the market price."

"A thousand pounds! Great Lord of mercy!" The commissionaire plumped down into a chair and stared from one to the other of us.

"That is the reward, and I have reason to know that there are sentimental considerations in the background that would induce the Countess to part with half her fortune if she could but recover the gem."

"It was lost, if I remember aright, at the Hotel Cosmopolitan," I remarked.

"Precisely so, on December 22nd, just five days ago. John Horner, a plumber, was accused of having abstracted it from the lady's jewel case. The evidence against him was so strong that the case has been referred to the Assizes. I have some account of the matter here, I believe." He rummaged amid his newspapers, glancing over the dates, until at last he smoothed one out, doubled it over, and read the following paragraph:

Hotel Cosmopolitan Jewel Robbery. John Horner, twenty-six, plumber, was brought up upon the charge of having upon the 22nd inst., abstracted from the jewel case of the Countess of Morcar the valuable gem known as the blue carbuncle. James Ryder, upper attendant at the hotel, gave his evidence to the effect that he had shown Horner up to

the dressing room of the Countess of Morcar upon the day of the robbery in order that he might solder the second bar of the grate, which was loose. He had remained with Horner some little time but had finally been called away. On returning he found that Horner had disappeared, that the bureau had been forced open, and that the small morocco casket in which, as it afterwards transpired, the Countess was accustomed to keep her jewel, was lying empty upon the dressing table. Ryder instantly gave the alarm, and Horner was arrested the same evening; but the stone could not be found either upon his person or in his rooms. Catherine Cusack, maid to the Countess, deposed to having heard Ryder's cry of dismay on discovering the robbery, and to having rushed into the room, where she found matters as described by the last witness. Inspector Bradstreet, B division, gave evidence as to the arrest of Horner, who struggled frantically and protested his innocence in the strongest terms. Evidence of a previous conviction for robbery having been given against the prisoner, the magistrate refused to deal summarily with the offence but referred it to the Assizes. Horner, who had shown signs of intense emotion during the proceedings, fainted away at the conclusion and was carried out of court._

Tureen in the form of a goose
ca. 1770

"Hum! So much for the police court," said Holmes thoughtfully, tossing aside the paper. "The question for us now to solve is the sequence of events leading from a rifled jewel case at one end to the crop of a goose in Tottenham Court Road at the other. You see, Watson, our little deductions have suddenly assumed a much more important and less innocent aspect. Here is the stone; the stone came from the goose, and the goose came from Mr. Henry Baker, the gentleman with the bad hat and all the other characteristics with which I have bored you. So now we must set ourselves very seriously to finding this gentleman and ascertaining what part he has played in this little mystery. To do this, we must try the simplest means first, and these lie undoubtedly in an advertisement in all the evening papers. If this fail, I shall have recourse to other methods."

"What will you say?"

"Give me a pencil and that slip of paper. Now then:

Found at the corner of Goodge Street, a goose and a black felt hat. Mr. Henry Baker can have the same by applying at 6:30 this evening at 221B Baker Street.

"That is clear and concise."

"Very. But will he see it?"

"Well he is sure to keep an eye on the papers, since, to a poor man, the loss was a heavy one. He was clearly so scared by his mischance in breaking the window and by the approach of Peterson that he thought of nothing but flight, but since then he must have bitterly regretted the impulse that caused him to drop his bird. Then again, the introduction of his name will cause him to see it, for everyone who knows him will direct his attention to it. Here you are, Peterson, run down to the advertising agency and have this put in the evening papers."

"In which, sir?"

"Oh, in the _Globe, Star, Pall Mall, St. James's, Evening News, Standard, Echo,_ and any others that occur to you."

"Very well, sir. And this stone?"

"Ah, yes, I shall keep the stone. Thank you. And, I say, Peterson, just buy a goose on your way back and leave it here with me, for we must have one to give to this gentleman in place of the one that your family is now devouring."

When the commissionaire had gone, Holmes took up the stone and held it against the light. "It's a bonny thing," said he. "Just see how it glints and sparkles. Of course it is a nucleus and focus of crime. Every good stone is. They are the devil's pet baits. In the larger and older jewels every facet may stand for a bloody deed. This stone is not yet twenty years old. It was found in the banks of the Amoy River in southern China and is remarkable in having every characteristic of the carbuncle, save that it is blue in shade instead of ruby red. In spite of its youth, it has already a sinister history. There have been two murders, a vitriol throwing, a suicide, and several robberies brought about for the sake of this forty-grain weight of crystallized charcoal. Who would think that so pretty a toy would be a purveyor to the gallows and the prison? I'll lock it up in my strongbox now and drop a line to the Countess to say that we have it."

"Do you think that this man Horner is innocent?"

"I cannot tell."

"Well then, do you imagine that this other one, Henry Baker, had anything to do with the matter?"

"It is, I think, much more likely that Henry Baker is an absolutely innocent man, who had no idea that the bird he was carrying was of considerably more value than if it were made of solid gold. That, however, I shall determine by a very simple test if we have an answer to our advertisement."

"And you can do nothing until then?"

"Nothing."

"In that case I shall continue my professional round. But I shall come back in the evening at the hour you have mentioned, for I should like to see the solution of so tangled a business."

"Very glad to see you. I dine at seven. There is a woodcock, I believe. By the way, in view of recent occurrences, perhaps I ought to ask Mrs. Hudson to examine its crop."

I had been delayed at a case, and it was a little after half-past six when I found myself in Baker Street once more. As I approached the house I saw a tall man in a Scotch bonnet with a coat that was buttoned up to his chin waiting outside in the bright semicircle that was thrown from the fanlight. Just as I arrived the door was opened, and we were shown up together to Holmes's room.

"Mr. Henry Baker, I believe," said he, rising from his armchair and greeting his visitor with the easy air of geniality that he could so readily assume. "Pray take this chair by the fire, Mr. Baker. It is a cold night, and I observe that your circulation is more adapted for summer than for winter. Ah, Watson, you have just come at the right time. Is that your hat, Mr. Baker?"

"Yes, sir, that is undoubtedly my hat."

He was a large man with rounded shoulders, a massive head, and a broad, intelligent face, sloping down to a pointed beard of grizzled brown. A touch of red in nose and cheeks, with a slight tremor of his extended hand, recalled Holmes's surmise as to his habits. His rusty black frock coat was buttoned right up in front with the collar turned up, and his lank wrists protruded from his sleeves without a sign of cuff or shirt. He spoke in a slow staccato fashion, choosing his words with care, and gave the impression generally of a man of learning and letters who had had ill usage at the hands of fortune.

"We have retained these things for some days," said Holmes, "because we expected to see an advertisement from you giving your address. I am at a loss to know now why you did not advertise."

Our visitor gave a rather shamefaced laugh. "Shillings have not been so plentiful with me as they once were," he remarked. "I had no doubt that the gang of roughs who assaulted me had carried off both my hat and the bird. I did not care to spend more money in a hopeless attempt at recovering them."

"Very naturally. By the way, about the bird, we were compelled to eat it."

"To eat it!" Our visitor half rose from his chair in his excitement.

"Yes, it would have been of no use to anyone had we not done so. But I presume that this other goose upon the sideboard, which is about the same weight and perfectly fresh, will answer your purpose equally well?"

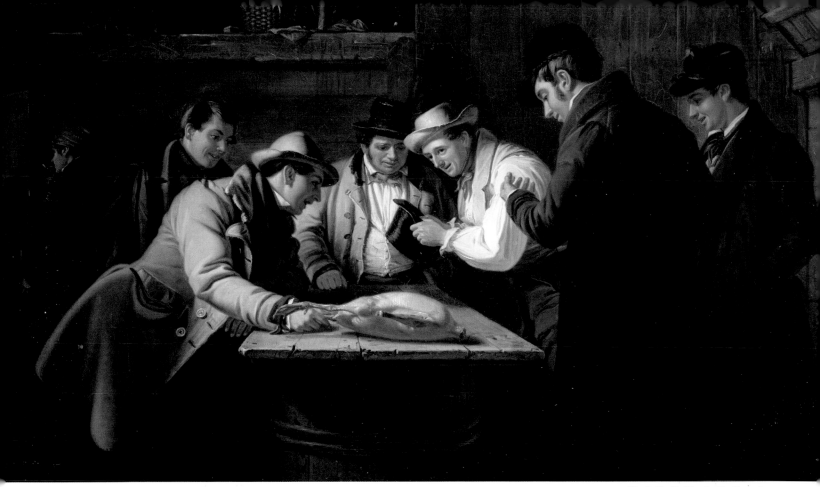

The Raffle (Raffling for the Goose)
1837, William Sidney Mount

"Oh, certainly, certainly," answered Mr. Baker with a sigh of relief.

"Of course, we still have the feathers, legs, crop, and so on of your own bird, so if you wish—"

The man burst into a hearty laugh. "They might be useful to me as relics of my adventure," said he, "but beyond that I can hardly see what use the *disjecta membra* of my late acquaintance are going to be to me. No, sir, I think that, with your permission, I will confine my attentions to the excellent bird that I perceive upon the sideboard."

Sherlock Holmes glanced sharply across at me with a slight shrug of his shoulders.

"There is your hat then and there your bird," said he. "By the way, would it bore you to tell me where you got the other one from? I am somewhat of a fowl fancier, and I have seldom seen a better grown goose."

"Certainly, sir," said Baker, who had risen and tucked his newly gained property under his arm. "There are a few of us who frequent the Alpha Inn, near the museum—we are to be found in the museum itself during the day, you understand.

This year our good host, Windigate by name, instituted a goose club, by which, on consideration of some few pence every week, we were each to receive a bird at Christmas. My pence were duly paid, and the rest is familiar to you. I am much indebted to you, sir, for a Scotch bonnet is fitted neither to my years nor my gravity." With a comical pomposity of manner, he bowed solemnly to both of us and strode off upon his way.

"So much for Mr. Henry Baker," said Holmes when he had closed the door behind him. "It is quite certain that he knows nothing whatever about the matter. Are you hungry, Watson?"

"Not particularly."

"Then I suggest that we turn our dinner into a supper and follow up this clue while it is still hot."

"By all means."

It was a bitter night, so we drew on our ulsters and wrapped cravats about our throats. Outside, the stars were shining coldly in a cloudless sky, and the breath of the passersby blew out into smoke like so many pistol shots. Our footfalls rang out crisply and loudly as we swung through the

Goose Hiding its Head
1895–97, Alfred Sisley

He rushed fiercely forward, and the inquirer flitted away into the darkness.

"Ha! This may save us a visit to Brixton Road," whispered Holmes. "Come with me, and we will see what is to be made of this fellow." Striding through the scattered knots of people who lounged round the flaring stalls, my companion speedily overtook the little man and touched him upon the shoulder. He sprang round, and I could see in the gaslight that every vestige of color had been driven from his face.

"Who are you then? What do you want?" he asked in a quavering voice.

"You will excuse me," said Holmes blandly, "but I could not help overhearing the questions that you put to the salesman just now. I think that I could be of assistance to you."

"You? Who are you? How could you know anything of the matter?"

"My name is Sherlock Holmes. It is my business to know what other people don't know."

"But you can know nothing of this?"

"Excuse me, I know everything of it. You are endeavoring to trace some geese that were sold by Mrs. Oakshott of Brixton Road to a salesman named Breckinridge, by him in turn to Mr. Windigate of the Alpha, and by him to his club, of which Mr. Henry Baker is a member."

"Oh, sir, you are the very man whom I have longed to meet," cried the little fellow with outstretched hands and quivering fingers. "I can hardly explain to you how interested I am in this matter."

Sherlock Holmes hailed a four-wheeler that was passing. "In that case we had better discuss it in a cozy room rather than in this windswept marketplace," said he. "But pray tell me, before we go farther, who it is that I have the pleasure of assisting."

The man hesitated for an instant. "My name is John Robinson," he answered with a sidelong glance.

"No, no, the real name," said Holmes sweetly. "It is always awkward doing business with an alias."

A flush sprang to the white cheeks of the stranger. "Well then," said he, "my real name is James Ryder."

"Precisely so. Head attendant at the Hotel Cosmopolitan. Pray step into the cab, and I shall soon be able to tell you everything that you would wish to know."

The little man stood glancing from one to the other of us with half-frightened, half-hopeful eyes, as one who is not sure whether he is on the verge of a windfall or of a catastrophe. Then he stepped into the cab, and in half an hour we were back in the sitting room at Baker Street. Nothing had been said during our drive, but the high, thin breathing of our new companion, and the clasping and unclasping of his hands, spoke of the nervous tension within him.

"Here we are!" said Holmes cheerily as we filed into the room. "The fire looks very seasonable in this weather. You look cold, Mr. Ryder. Pray take the basket chair. I will just put on my slippers before we settle this little matter of yours. Now then! You want to know what became of those geese?"

"Yes, sir."

"Or rather, I fancy, of that goose. It was one bird I imagine in which you were interested—white, with a black bar across the tail."

Ryder quivered with emotion. "Oh, sir," he cried, "can you tell me where it went to?"

"It came here."

"Here?"

"Yes, and a most remarkable bird it proved. I don't wonder that you should take an interest in it. It laid an egg after it was dead—the bonniest, brightest little blue egg that ever was seen. I have it here in my museum."

Our visitor staggered to his feet and clutched the mantelpiece with his right hand. Holmes unlocked his strongbox and held up the blue carbuncle, which shone out like a star, with a cold, brilliant, many-pointed radiance. Ryder stood glaring with a drawn face, uncertain whether to claim or to disown it.

"The game's up, Ryder," said Holmes quietly. "Hold up, man, or you'll be into the fire! Give him an arm back into his chair, Watson. He's not got blood enough to go in for felony with impunity. Give him a dash of brandy. So! Now he looks a little more human. What a shrimp it is, to be sure!"

For a moment he had staggered and nearly fallen, but the brandy brought a tinge of color into his cheeks, and he sat staring with frightened eyes at his accuser.

"I have almost every link in my hands, and all the proofs that I could possibly need, so there is little that you need tell me. Still, that little may as well be cleared up to make the case complete. You had heard, Ryder, of this blue stone of the Countess of Morcar's?"

Two Geese Walking
1895–97, Alfred Sisley

"It was Catherine Cusack who told me of it," said he in a crackling voice.

"I see—her ladyship's waiting maid. Well, the temptation of sudden wealth so easily acquired was too much for you, as it has been for better men before you; but you were not very scrupulous in the means you used. It seems to me, Ryder, that there is the making of a very pretty villain in you. You knew that this man Horner, the plumber, had been concerned in some such matter before, and that suspicion would rest the more readily upon him. What did you do then? You made some small job in my lady's room—you and your confederate Cusack—and you managed that he should be the man sent for. Then when he had left, you rifled the jewel case, raised the alarm, and had this unfortunate man arrested. You then—"

Ryder threw himself down suddenly upon the rug and clutched at my companion's knees. "For God's sake, have mercy!" he shrieked. "Think of my father! Of my mother! It would break their hearts. I never went wrong before! I never will again. I swear it. I'll swear it on a Bible. Oh, don't bring it into court! For Christ's sake, don't!"

"Get back into your chair!" said Holmes sternly. "It is very well to cringe and crawl now, but you thought little enough of this poor Horner in the dock for a crime of which he knew nothing."

"I will fly, Mr. Holmes. I will leave the country, sir. Then the charge against him will break down."

"Hum! We will talk about that. And now let us hear a true account of the next act. How came the stone into the goose, and how came the goose into the open market? Tell us the truth, for there lies your only hope of safety."

Ryder passed his tongue over his parched lips. "I will tell you it just as it happened, sir," said he. "When Horner had been arrested, it seemed to me that it would be best for me to get away with the stone at once, for I did not know at what moment the police might not take it into their heads to search me and my room. There was no place about the hotel where it would be safe. I went out, as if on some commission, and I made for my sister's house. She had married a man named Oakshott and lived in Brixton Road where she fattened fowls for the market. All the way there every man I met seemed to me to be a policeman or a detective; and, for all that it was a cold night, the sweat was pouring down my face before I came to the Brixton Road. My sister asked me what was the matter and why I was so pale; but I told her that I had been upset by the jewel robbery at the hotel. Then I went into the backyard and smoked a pipe and wondered what it would be best to do.

"I had a friend once called Maudsley, who went to the bad and has just been serving his time in Pentonville. One day he had met me and fell into talk about the ways of thieves and how they could get rid of what they stole. I knew that he would be true to me, for I knew one or two things about him; so I made up my mind to go right on to Kilburn where he lived and take him into my confidence. He would show me how to turn the stone into money. But how to get to him in safety? I thought of the agonies I had gone through in coming from the hotel. I might at any moment be seized and searched, and there would be the stone in my waistcoat pocket. I was leaning against the wall at the time and looking at the geese that were waddling about round my feet, and suddenly an idea came into my head that showed me how I could beat the best detective that ever lived.

"My sister had told me some weeks before that I might have the pick of her geese for a Christmas present, and I knew that she was always as good as her word. I would take my goose now, and in it I would carry my stone to Kilburn. There was a little shed in the yard, and behind this I drove one of the birds—a fine big one, white, with a barred tail. I caught it, and prying its bill open, I thrust the stone down its throat as far as my finger could reach. The bird gave a gulp, and I felt the stone pass along its gullet and down into its crop. But the creature flapped and struggled, and out came my sister to know what was the matter. As I turned to speak to her, the brute broke loose and fluttered off among the others.

"'Whatever were you doing with that bird, Jem?' says she.

"'Well,' said I, 'you said you'd give me one for Christmas, and I was feeling which was the fattest.'

"'Oh,' says she, 'we've set yours aside for you—Jem's bird, we call it. It's the big white one over yonder. There's twenty-six of them, which makes one for you and one for us and two dozen for the market.'

"'Thank you, Maggie,' says I; 'but if it is all the same to you, I'd rather have that one I was handling just now.'

"'The other is a good three pound heavier,' said she, 'and we fattened it expressly for you.'

"'Never mind. I'll have the other, and I'll take it now,' said I.

"'Oh, just as you like,' said she, a little huffed. 'Which is it you want then?'

"'That white one with the barred tail, right in the middle of the flock.'

"'Oh, very well. Kill it and take it with you.'

"Well, I did what she said, Mr. Holmes, and I carried the bird all the way to Kilburn. I told my pal what I had done, for he was a man that it was easy to tell a thing like that to. He laughed until he choked, and we got a knife and opened the goose. My heart turned to water, for there was no sign of the stone, and I knew that some terrible mistake had occurred. I left the bird, rushed back to my sister's, and hurried into the backyard. There was not a bird to be seen there.

"'Where are they all, Maggie?' I cried.

"'Gone to the dealer's, Jem.'

"'Which dealer's?'

"'Breckinridge of Covent Garden.'

"'But was there another with a barred tail?' I asked, 'the same as the one I chose?'

"'Yes, Jem, there were two barred-tailed ones, and I could never tell them apart.'

"Well then, of course I saw it all, and I ran off as hard as my feet would carry me to this man Breckinridge; but he had sold the lot at once, and not one word would he tell me as to where they had gone. You heard him your-selves tonight. Well, he has always answered me like that. My sister thinks that I am going mad. Sometimes I think that I am myself. And now—

and now I am myself a branded thief, without ever having touched the wealth for which I sold my character. God help me! God help me!" He burst into convulsive sobbing with his face buried in his hands.

There was a long silence, broken only by his heavy breathing and by the measured tapping of Sherlock Holmes's fingertips upon the edge of the table. Then my friend rose and threw open the door.

"Get out!" said he.

"What, sir! Oh, Heaven bless you!"

"No more words. Get out!"

And no more words were needed. There was a rush, a clatter upon the stairs, the bang of a door, and the crisp rattle of running footfalls from the street.

"After all, Watson," said Holmes, reaching up his hand for his clay pipe, "I am not retained by the police to supply their deficiencies. If Horner were in danger it would be another thing; but this fellow will not appear against him, and the case must collapse. I suppose that I am commuting a felony, but it is just possible that I am saving a soul. This fellow will not go wrong again; he is too terribly frightened. Send him to jail now, and you make him a jailbird for life. Besides, Christmas, it is the season of forgiveness. Chance has put in our way a most singular and whimsical problem, and its solution is its own reward."

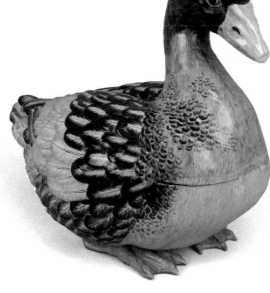

Tureen in the form of a goose (one of a pair)
1750

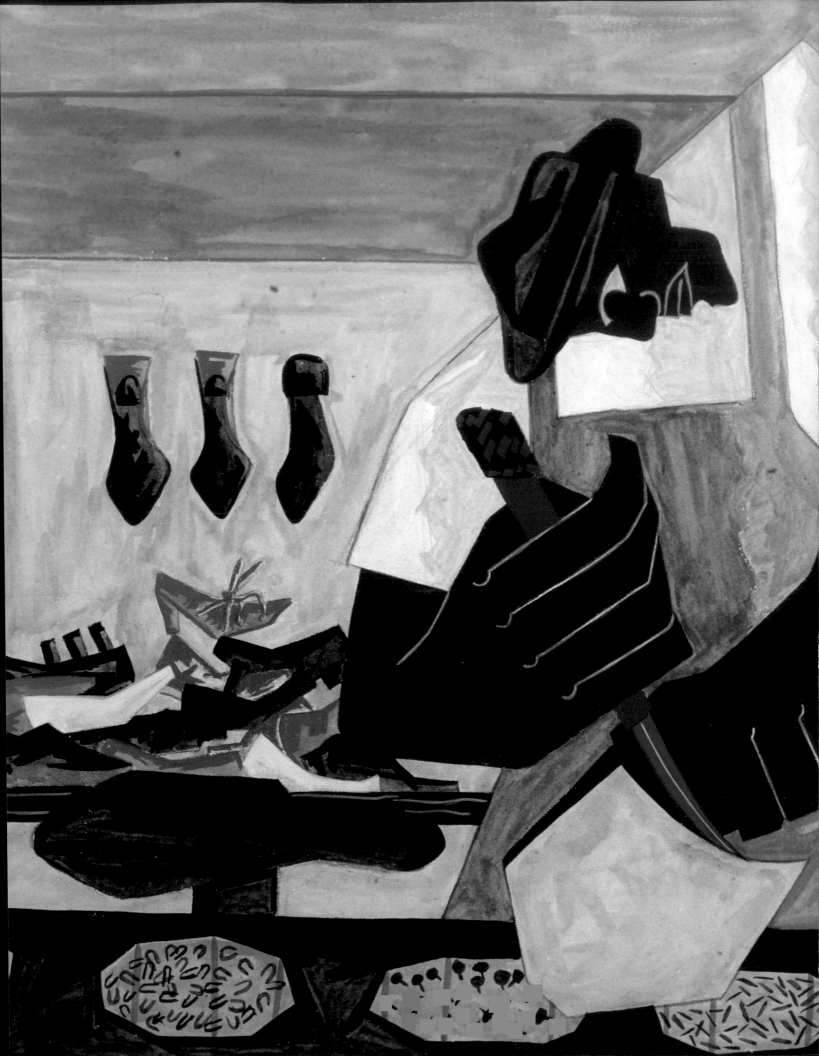

The Elves and the Shoemaker

By Brothers Grimm

There was once a shoemaker, who worked very hard and was very honest: but still he could not earn enough for he and his wife to live upon. At last all he had in the world was gone, save just leather enough to make one pair of shoes.

So he cut his leather out, all ready to make up the next day, meaning to rise early in the morning to his work. His conscience was clear and his heart light amidst all his troubles; so he and his wife went peaceably to bed, leaving their cares to Heaven, and soon fell asleep.

In the morning after he had said his prayers, he sat himself down to his work; when, to his great wonder, there stood the shoes already made, upon the table. The good man knew not what to say or think at such an odd thing happening. He looked at the workmanship; there was not one false stitch in the whole job; all was so neat and true, that it was quite a masterpiece. He called to his wife and she too marveled at the occurrence.

The same day a customer came in, and the shoes suited him so well that he willingly paid a price higher than usual for them; and the poor shoemaker, with the money, bought leather enough to make two pairs more. In the evening he cut out the work, and went to bed early, that he might get up and begin betimes next day; but he was saved all the trouble, for when he got up in the morning the work was done ready to his hand. Again he and his wife could not understand what had happened.

Soon in came buyers, who paid him handsomely for his goods, so that he bought leather enough for four pair more. He cut out the work again overnight and found it done in the morning, as before; and so it went on for some time: what was got ready in the evening was always done by daybreak, and the good man and his wife soon became thriving and well off again.

One evening, about Christmastime, as he and his wife were sitting over the fire chatting together, he said to her, "I should like to sit up and watch tonight, that we may see who it is that comes and does my work for me." The wife liked the thought; so they left a light burning, and hid themselves in a corner of the room, behind a curtain that was hung up there, and watched what would happen.

As soon as it was midnight, there came in two little naked dwarfs. And they sat themselves upon the shoemaker's bench, took up all the work

The Shoemaker (detail)
1945, Jacob Lawrence

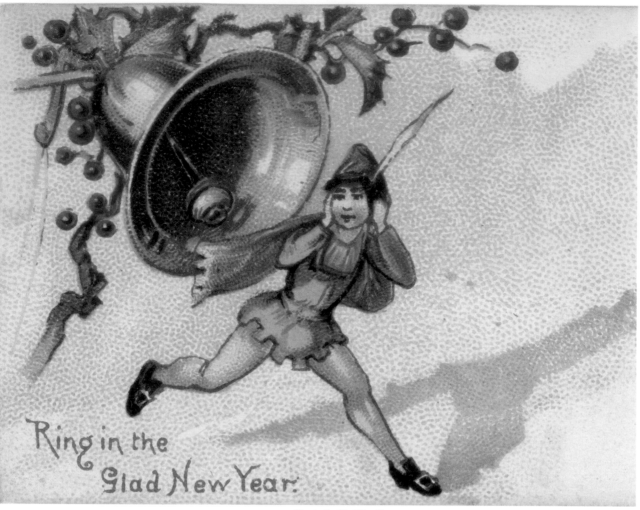

Ring in the
Glad New Year.

Ring in the Glad New Year, from the New Years 1890 series (N227) issued by Kinney Bros., 1889–90

that was cut out, and began to ply with their little fingers, stitching and rapping and tapping away at such a rate that the shoemaker was all wonder and could not take his eyes off them. And on they went, till the job was quite done, and the shoes stood ready for use upon the table. This was long before daybreak; and then they bustled away as quick as lightning.

The next day the wife said to the shoemaker, "These little wights have made us rich, and we ought to be thankful to them, and do them a good turn if we can. I am quite sorry to see them run about as they do; and indeed it is not very decent, for they have nothing upon their backs to keep off the cold. I'll tell you what, I will make each of them a shirt, and a coat and waistcoat, and a pair of pantaloons into the bargain; and do you make each of them a little pair of shoes."

The thought pleased the good cobbler very

much; and on Christmas Eve, when all the things were ready, they laid them on the table, instead of the work that they used to cut out, and then went and hid themselves, to watch what the little elves would do.

About midnight in they came, dancing and skipping, hopped round the room, and then went to sit down to their work as usual; but when the elves saw the clothes lying for them, they laughed and chuckled, and seemed mightily delighted.

The elves dressed themselves in the twinkling of an eye, and danced and capered and sprang about, as merry as could be; till at last they danced out at the door, and away over the snowy green.

The good couple saw them no more; but everything went well with them from that time forward, as long as they lived.

KEEPING CHRISTMAS

A CHRISTMAS READING BY HENRY VAN DYKE

It is a good thing to observe Christmas day. The mere marking of times and seasons, when men agree to stop work and make merry together, is a wise and wholesome custom. It helps one to feel the supremacy of the common life over the individual life. It reminds a man to set his own little watch, now and then, by the great clock of humanity, which runs on sun time.

But there is a better thing than the observance of Christmas day, and that is, keeping Christmas.

Are you willing to forget what you have done for other people, and to remember what other people have done for you; to ignore what the world owes you, and to think what you owe the world; to put your rights in the background, and your duties in the middle distance, and your chances to do a little more than your duty in the foreground; to see that your fellow men are just as real as you are, and try to look behind their faces to their hearts, hungry for joy; to own that probably the only good reason for your existence is not what you are going to get out of life, but what you are going to give to life; to close your book of complaints against the management of the universe, and look around you for a place where you can sow a few seeds of happiness—are you willing to do these things even for a day? Then you can keep Christmas.

The Jefferson R. Burdick Collection

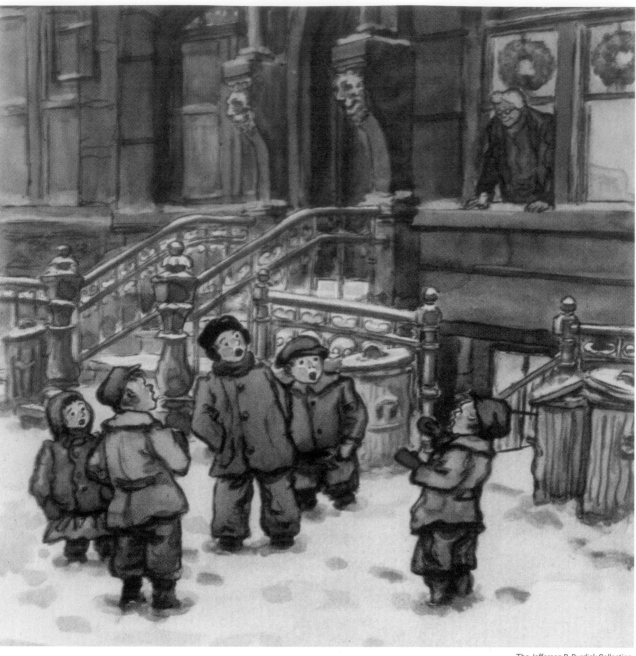

Are you willing to stoop down and consider the needs and the desires of little children; to remember the weakness and loneliness of people who are growing old; to stop asking how much your friends love you, and ask yourself whether you love them enough; to bear in mind the things that other people have to bear on their hearts; to try to understand what those who live in the same house with you really want, without waiting for them to tell you; to trim your lamp so that it will give more light and less smoke, and to carry it in front so that your shadow will fall behind you; to make a grave for your ugly thoughts, and a garden for your kindly feelings, with the gate open—are you willing to do these things even for a day? Then you can keep Christmas.

Are you willing to believe that love is the strongest thing in the world—stronger than hate, stronger than evil, stronger than death—and that the blessed life that began in Bethlehem nineteen hundred years ago is the image and brightness of the Eternal Love? Then you can keep Christmas.

And if you keep it for a day, why not always? But you can never keep it alone.

Little Women,
A Merry Christmas

By Louisa May Alcott

(Excerpt from Part One, Chapter Two)

Jungle Tales (Contes de la Jungle)
1895, James Jebusa Shannon

Jo was the first to wake in the gray dawn of Christmas morning. No stockings hung at the fireplace, and for a moment she felt as much disappointed as she did long ago when her little sock fell down because it was crammed so full of goodies. Then she remembered her mother's promise and, slipping her hand under her pillow, drew out a little crimson-covered book. She knew it very well, for it was that beautiful old story of the best life ever lived, and Jo felt that it was a true guidebook for any pilgrim going on a long journey. She woke Meg with a "Merry Christmas" and bade her see what was under her pillow. A green-covered book appeared with the same picture inside and a few words written by their mother, which made their one present very precious in their eyes. Presently Beth and Amy woke to

rummage and find their little books also, one dove-colored, the other blue, and all sat looking at and talking about them while the east grew rosy with the coming day.

In spite of her small vanities, Margaret, whom her sisters called Meg, had a sweet and pious nature, which unconsciously influenced her sisters, especially Jo, who loved her very tenderly and obeyed her because her advice was so gently given.

"Girls," said Meg seriously, looking from the tumbled head beside her to the two little night-capped ones in the room beyond. "Mother wants us to read and love and mind these books, and we must begin at once. We used to be faithful about it, but since Father went away to war and all this fighting trouble unsettled us, we have neglected many things. You can do as you please, but I shall keep my book on the table here and read a little every morning as soon as I wake, for I know it will do me good and help me through the day."

Then she opened her new book and began to read. Jo put her arm round her and, leaning cheek to cheek, read also with the quiet expression so seldom seen on her restless face.

"How good Meg is! Come, Amy, let's do as they do. I'll help you with the hard words, and they will explain things if we don't understand," whispered Beth, very much impressed by the pretty books and her sisters' example.

"I'm glad mine is blue," said Amy. And then the rooms were very still while the pages were softly turned, and the winter sunshine crept in to touch the bright heads and serious faces with a Christmas greeting.

"Where is Mother?" asked Meg, as she and Jo ran down to thank her for their gifts half an hour later.

"Goodness only knows. Some poor creature came a-beggin', and your ma went straight off to see what was needed. There never was such a woman for givin' away vittles and drink, clothes and firin'," replied Hannah, who had lived with the family since Meg was born and was considered by them all more as a friend than a servant.

"She will be back soon, I think, so fry your cakes and have everything ready," said Meg, looking over the presents, which were collected in a basket and kept under the sofa, ready to be produced at the proper time. "Why, where is Amy's bottle of cologne?" she added, as the little flask did not appear.

"She took it out a minute ago, and went off with it to put a ribbon on it, or some such notion," replied Jo, dancing about in the stiff new slippers she was giving Marmee to soften them.

"How nice my handkerchiefs look, don't they? Hannah washed and ironed them for me, and I marked them all myself," said Beth, looking proudly at the somewhat uneven letters that had cost her such labor.

"Bless the child! She's gone and put 'Mother' on them instead of 'M. March.' How funny!" cried Jo, taking one up.

"Isn't that right? I thought it was better to do it so, because Meg's initials are 'M. M.,' and I don't want anyone to use these but Marmee," said Beth, looking troubled.

"It's all right, dear, and a very pretty idea—quite sensible, too, for no one can ever mistake now. It will please her very much, I know," said Meg, with a frown for Jo and a smile for Beth.

"There's Mother. Hide the basket, quick!" cried Jo, as a door slammed and steps sounded in the hall.

Amy came in hastily and looked rather abashed when she saw her sisters all waiting for her.

"Where have you been, and what are you hiding behind you?" asked Meg, surprised to see, by her hood and cloak, that lazy Amy had been out so early.

"Don't laugh at me, Jo! I didn't mean anyone should know till the time came. I only meant to change the little bottle for a big one, and I gave all my money to get it, and I'm truly trying not to be selfish anymore."

As she spoke, Amy showed the handsome flask that replaced the cheap one and looked so earnest and humble in her little effort to forget herself that Meg hugged her on the spot, and

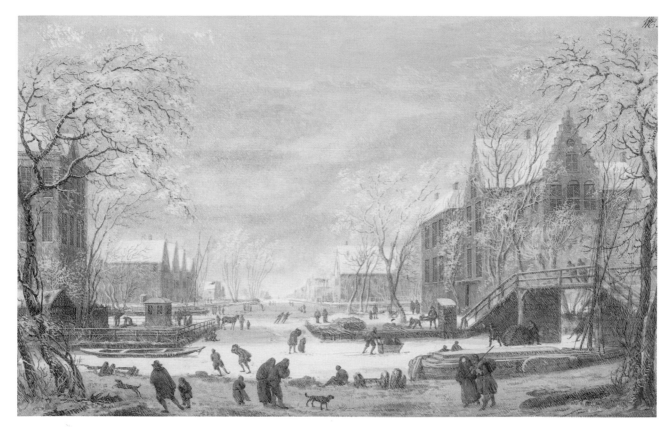

Snow Falling on a Dutch Town
n.d., Abraham Rademaker

Jo pronounced her "a trump," while Beth ran to the window and picked her finest rose to ornament the stately bottle.

"You see I felt ashamed of my present after reading and talking about being good this morning, so I ran round the corner and changed it the minute I was up, and I'm so glad, for mine is the handsomest now."

Another bang of the street door sent the basket under the sofa, and the girls to the table, eager for breakfast.

"Merry Christmas, Marmee! Many of them! Thank you for our books. We read some and mean to every day," they all cried in chorus.

"Merry Christmas, little daughters! I'm glad you began at once, and hope you will keep on. But I want to say one word before we sit down. Not far away from here lies a poor woman with a little newborn baby. Six children are huddled into one bed to keep from freezing, for they have no fire. There is nothing to eat over there, and the oldest boy came to tell me they were suffering hunger and cold. My girls, will you give them your breakfasts as a Christmas present?"

They were all unusually hungry, having waited nearly an hour, and for a minute no one spoke—only a minute, for Jo exclaimed impetuously, "I'm so glad you came before we began!"

"May I go and help carry the things to the poor little children?" asked Beth eagerly.

"I shall take the cream and the muffins," added Amy, heroically giving up the article she most liked.

Meg was already covering the buckwheats and piling the bread into one big plate.

"I thought you'd do it," said Mrs. March, smiling as if satisfied. "You shall all go and help me, and when we come back we will have bread and milk for breakfast and make it up at dinnertime."

They were soon ready, and the procession set out. Fortunately it was early, and they went through backstreets, so few people saw them, and no one laughed at the queer party.

Indeed it was a poor, bare, and miserable room with broken windows, no fire, ragged

bedclothes, a sick mother, wailing baby, and a group of pale, hungry children cuddled under one old quilt trying to keep warm.

How the big eyes stared and the blue lips smiled as the girls went in!

"Ach, mein Gott! It is good angels come to us!" said the poor woman, Mrs. Hummel, crying for joy.

"Funny angels in hoods and mittens," said Jo, and set them to laughing.

In a few minutes it really did seem as if kind spirits had been at work there. Hannah, who had carried wood, made a fire, and stopped up the broken panes with old hats and her own cloak. Mrs. March gave the mother tea and gruel and comforted her with promises of help while she dressed the little baby as tenderly as if it had been her own. The girls meantime spread the table, set the children round the fire, and fed them like so many hungry birds, laughing, talking, and trying to understand the broken English.

"Das ist gut! Die Engel-kinder!" cried the poor things as they ate and warmed their purple hands at the comfortable blaze.

The girls had never been called angel children before, and thought it very agreeable. That was a very happy breakfast, though they didn't get any of it. And when they went away, leaving comfort behind, I think there were not in all the city four merrier people than the hungry little girls who gave away their breakfasts and contented themselves with bread and milk on Christmas morning.

"That's loving our neighbor better than ourselves, and I like it," said Meg, as they set out their presents while their mother was upstairs collecting clothes for the poor Hummels.

Not a very splendid show, but there was a great deal of love done up in the few little bundles, and the tall vase of red roses, white chrysanthemums, and trailing vines, which stood in the middle, gave quite an elegant air to the table.

"She's coming! Strike up, Beth! Open the door, Amy! Three cheers for Marmee!" cried Jo, prancing about while Meg went to conduct Mother to the seat of honor.

Beth played her gayest march at the piano, Amy threw open the door, and Meg enacted escort with great dignity. Mrs. March was both surprised and touched, and smiled with her eyes full as she examined her presents and read the little notes that accompanied them. The slippers went on at once, a new handkerchief was slipped into her pocket, well scented with Amy's cologne, the rose was fastened in her bosom, and the nice gloves were pronounced a "perfect fit."

There was a good deal of laughing and kissing and explaining in the simple, loving fashion that makes these home festivals so pleasant at the time, so sweet to remember long afterward, and then all fell to work.

The morning charities and ceremonies took so much time that the rest of the day was devoted to preparations for the evening festivities. Being still too young to go often to the theater and not rich enough to afford any great outlay for private performances, the girls put their wits to work, and necessity being the mother of invention, made whatever theatrics they needed. Very clever were some of their productions: pasteboard guitars, antique lampshade of old-fashioned butter boats covered with silver paper, gorgeous robes of old cotton, glittering with tin spangles from a pickle factory, and armor covered with the same useful diamond-shaped bits left in sheets when the lids of preserve pots were cut out. The big chamber was the scene of many innocent revels.

On Christmas night a dozen girls piled onto the bed, which was the dress circle, and sat before the blue-and-yellow chintz curtains in a most flattering state of expectancy. There was a good deal of rustling and whispering behind the curtain, a trifle of lamp smoke, and an occasional giggle from Amy, who was apt to get hysterical in the excitement of the moment. Presently a bell sounded, the curtains flew apart, and the Operatic Tragedy began.

Tumultuous applause concluded the evening's theatrics but received an unexpected check, for the cot bed, on which the dress circle was built, suddenly shut up and extinguished the enthusiastic audience. The sisters flew to the rescue, and all their friends were taken out unhurt, though many were speechless with laughter. The excitement had hardly subsided when Hannah appeared and announced, "With Mrs. March's compliments, would the ladies walk down to supper."

This was a surprise even to the actors, and when they saw the table, they looked at one another in rapturous amazement. It was like Marmee to get up a little treat for them, but anything so fine as this was unheard of since the departed days of plenty. There was ice cream, actually two dishes of it, pink and white, and cake and fruit and distracting French bonbons and, in the middle of the table, four great bouquets of hothouse flowers.

It quite took their breath away, and they stared first at the table and then at their mother, who looked as if she enjoyed it immensely.

"Is it fairies?" asked Amy.

"It's Santa Claus," said Beth.

"Mother did it." And Meg smiled her sweetest, in spite of her gray beard and white eyebrows.

"Aunt March had a good fit and sent the supper," cried Jo, with a sudden inspiration.

"All wrong. Old Mr. Laurence sent it," replied Mrs. March.

"The Laurence boy's grandfather! What in the world put such a thing into his head? We don't know him!" exclaimed Meg.

"Hannah told one of his servants about your breakfast party. He is an odd old gentleman, but that pleased him. He knew my father years ago, and he sent me a polite note this afternoon, saying he hoped I would allow him to express his friendly feeling toward my children by sending them a few trifles in honor of the day. I could not refuse, and so you have a little feast at night to make up for the bread-and-milk breakfast."

"That boy put it into his head, I know he did! He's a capital fellow, and I wish we could get acquainted. He looks as if he'd like to know us but he's bashful, and Meg is so prim she won't let me speak to him when we pass," said Jo, as the plates went round, and the ice began to melt out of sight, with ohs and ahs of satisfaction.

"You mean the people who live in the big house next door, don't you?" asked one of the girls. "My mother knows old Mr. Laurence but says he's very proud and doesn't like to mix with his neighbors. He keeps his grandson shut up when he isn't riding or walking with his tutor and makes him study very hard. We invited him to our party, but he didn't come. Mother says he's very nice, though he never speaks to us girls."

"Our cat ran away once, and he brought her back, and we talked over the fence and were getting on capitally, all about cricket and so on, when he saw Meg coming and walked off. I mean to know him some day, for he needs fun, I'm sure he does," said Jo decidedly.

"I like his manners, and he looks like a little gentleman, so I've no objection to your knowing him, if a proper opportunity comes. He brought the flowers himself, and I should have asked him in, if I had been sure what was going on upstairs. He looked so wistful as he went away, hearing the frolic and evidently having none of his own."

"It's a mercy you didn't, Mother!" laughed Jo, looking at her boots. "But we'll have another play sometime that he can see. Perhaps he'll help act. Wouldn't that be jolly?"

"I never had such a fine bouquet before! How pretty it is!" And Meg examined her flowers with great interest.

"They are lovely. But Beth's roses are sweeter to me," said Mrs. March, smelling the half-dead posy in her belt.

Beth nestled up to her and whispered softly, "I wish I could send my bunch to Father. I'm afraid he isn't having such a merry Christmas as we are."

Made up a Christmas bundle
All tied with ribbons gay,
And marked it, "For the Brownie,"
With "A Merry Christmas Day!"

And then in the winter twilight,
With shouts of loving glee,
They hied to the wood, and left their gift
Under the great oak-tree.

While the farmer's fair little children
Slept sweet that Christmas night,
Two wanderers through the forest
Came in the clear moonlight.

And neither of them was the Brownie,
But sorry were both as he;
And their hearts, with every footstep,
Were aching heavily.

A slender man with an organ
Strapped on by a leathern band,
And a little girl with a tambourine
A-holding close to his hand.

And the little girl with the tambourine,—
Her gown was thin and old;
And she toiled through the great white forest,
A-shining with the cold.

"And what is there here to do?" she said;
"I'm froze i' the light o' the moon!
Shall we play to these sad old forest trees
Some merry and jigging tune?

"And, father, you know it is Christmas-time;
And had we staid i' the town,
And I gone to one o' the Christmas-trees,
A gift might have fallen down!

"You cannot certainly know it would not!
I'd ha' gone right under the tree
Are you *sure* that never one Christmas
Is meant for you and me?"

"These dry, dead leaves," he answered her,
"Which the forest casteth down,
Are more than you'd get from a Christmas-tree
In the merry and thoughtless town.

"Though to-night be the Christ's own birthday night,
And all the world has grace,
There is not a home in all the world
Which has for us a place."

Slow plodding adown the forest path,
"Now, what is this?" he said;
Then he lifted the children's bundle,
And "For the Brownie," read.

The tears came into his weary eyes:
"Now if this be done," said he,
"Somewhere in the world perhaps there is
A place for you and me!"

Then the bundle he opened softly:
"This is children's tender thought;
Their own little Christmas presents
They have to the Brownie brought.

"If there lives such tender pity
Toward a thing so dim and low,
There must be kindness left on earth
Of which I did not know.

"Oh, children, there's never a Brownie
That sorry, uncanny thing;
But nearest and next are the homeless
When the Christmas joy-bells ring."

Loud laughed the little daughter,
As she gathered the toys in her gown:
"Oh, father, this oak is my Christmas-tree,
And my present has fallen down!"

Then away they went through the forest,
The wanderers, hand in hand;
And the snow, they were both so merry,
It glinted like golden sand.

Down the forest the elder brother,
In the morning clear and cold,
Came leading the little sister,
And the darling five-year-old.

"Oh," he cries, "he's taken the bundle!"
As carefully round he peers;
"And the Brownie has gotten a Christmas
After a thousand years!"

Happy New Year (detail)
from the New Years 1890 series (N227) issued by Kinney Bros.,

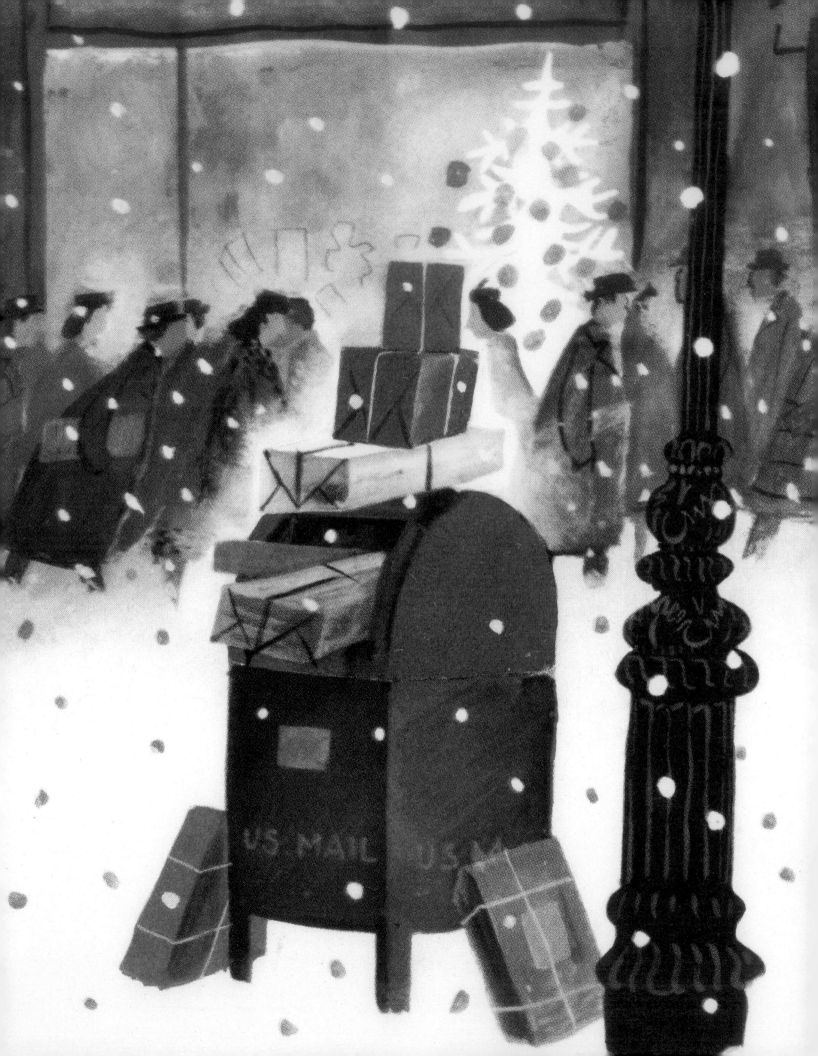

Uncle Richard's Christmas Dinner

By Lucy Maud Montgomery

(Originally published as Uncle Richard's New Year's Dinner)

> Lucy Maud Montgomery (November 30, 1874–April 24, 1942), published as L. M. Montgomery, was a Canadian author best known for a series of novels beginning in 1908 with *Anne of Green Gables*.

Prissy Baker was in Oscar Miller's store Christmas Eve morning, buying matches, when her uncle, Richard Baker, came in. He did not look at Prissy, nor did she wish him a very merry Christmas; she would not have dared. Uncle Richard had not been on speaking terms with her or her father, his only brother, for eight years.

He was a big, ruddy, prosperous-looking man—an uncle to be proud of, Prissy thought wistfully, if only he were like other people's uncles or, indeed, like what he used to be himself. He was the only uncle Prissy had, and when she had been a little girl they had been great friends; but that was before the quarrel, in which Prissy had had no share, to be sure, although Uncle Richard seemed to include her in his rancor.

Richard Baker, so he informed Mr. Miller, was on his way to Navarre with a load of pork.

"I didn't intend going over until the afternoon," he said, "but Joe Hemming sent word yesterday he wouldn't be buying pork after twelve today. So I have to tote my hogs over at once. I don't care about doing business the day before Christmas."

"Should think Christmas would be pretty much the same as any other day to you," said Mr. Miller, for Richard Baker was a bachelor, with only old Mrs. Janeway to keep house for him.

"Well, I always like a good dinner on Christmas Eve," said Richard Baker. "It's about the only way I can celebrate. Mrs. Janeway wanted to spend the day with her son's family over at Oriental, so I was laying out to cook my own dinner. I got everything ready in the pantry last night, 'fore I got word about the pork. I won't get back from Navarre before one o'clock, so I reckon I'll have to put up with a cold bite."

After her Uncle Richard had driven away, Prissy walked thoughtfully

home. She had planned to spend a nice, lazy holiday with a book and a box of candy. She did not even mean to cook a dinner for this evening but wait till Christmas Day, for her father had had to go to town that morning to meet a friend and would be gone till evening. There was nobody else to cook dinner for. Prissy's mother had died when Prissy was a baby. She was her father's housekeeper, and they had jolly times together.

But as she walked home, she could not help thinking about Uncle Richard. He would certainly have cold Christmas cheer, enough to chill the whole coming year. She felt sorry for him, picturing him returning from Navarre, cold and hungry, to find a fireless house and an uncooked dinner in the pantry.

Suddenly an idea popped into Prissy's head. Dared she? Oh, she never could! But he would never know . . . there would be plenty of time . . . she would!

Prissy hurried home, put her matches away, took a regretful peep at her unopened book, then locked the door and started up the road to Uncle Richard's house half a mile away. She meant to go and cook Uncle Richard's dinner for him, get it all beautifully ready, then slip away before he came home. He would never suspect her of it. Prissy would not have him suspect for the world; she thought he would be more likely to throw a dinner of her cooking out of doors than to eat it.

Eight years before this, when Prissy had been nine years old, Richard and Irving Baker had quarreled over the division of a piece of property. The fault had been mainly on Richard's side, and that very fact made him all the more unrelenting and stubborn. He had never spoken to his brother since, and he declared he never would. Prissy and her father felt very badly over it, but Uncle Richard did not seem to feel badly at all. To all appearance he had completely forgotten that there were such people in the world as his brother Irving and his niece Prissy.

Prissy had no trouble in breaking into Uncle Richard's house, for the woodshed door was unfastened. She tripped into the hostile kitchen with rosy cheeks and mischief sparkling in her eyes. This was an adventure—this was fun! She would tell her father all about it when he came home at night, and what a laugh they would have!

There was still a good fire in the stove, and in the pantry Prissy found the dinner in its raw state—a fine roast of fresh pork, potatoes, cabbage, turnips, and the ingredients of a raisin pudding, for Richard Baker was fond of raisin puddings and could make them as well as Mrs. Janeway could, if that was anything to boast of.

In a short time the kitchen was full of bubbling and hissings and appetizing odors. Prissy enjoyed herself hugely, and the raisin pudding, which she rather doubtfully mixed up, behaved itself beautifully.

"Uncle Richard said he'd be home by one," said Prissy to herself, as the clock struck twelve, "so I'll set the table now, dish up the dinner, and leave it where it will keep warm until he gets here. Then I'll slip away home. I'd like to see his face when he steps in. I suppose he'll think one of the Jenner girls across the street has cooked his dinner."

Prissy soon had the table set, and she was just peppering the turnips when a gruff voice behind her said:

"Well, well, what does this mean?"

Prissy whirled around as if she had been shot, and there stood Uncle Richard in the woodshed door!

Poor Prissy! She could not have looked or felt more guilty if Uncle Richard had caught her robbing his desk. She did not drop the turnips for a wonder; but she was too confused to set them down, so she stood there holding them, her face crimson, her heart thumping, and a horrible choking in her throat.

"I—I—came up to cook your dinner for you, Uncle Richard," she stammered. "I heard you say—in the store—that Mrs. Janeway had

gone home and that you had nobody to cook your Christmas dinner for you. So I thought I'd come and do it, but I meant to slip away before you came home."

Poor Prissy felt that she would never get to the end of her explanation. Would Uncle Richard be angry? Would he order her from the house?

"It was very kind of you," said Uncle Richard drily. "It's a wonder your father let you come."

"Father was not home, but I am sure he would not have prevented me if he had been. Father has no hard feelings against you, Uncle Richard."

"Humph!" said Uncle Richard. "Well, since you've cooked the dinner, you must stop and help me eat it. It smells good, I must say. Mrs. Janeway always burns pork when she roasts it. Sit down, Prissy. I'm hungry."

They sat down. Prissy felt quite giddy and breathless and could hardly eat for excitement; but Uncle Richard had evidently brought home a good appetite from Navarre, and he did full justice to his holiday dinner. He talked to Prissy, too, quite kindly and politely, and when the meal was over he said slowly:

"I'm much obliged to you, Prissy, and I don't mind owning to you that I'm sorry for my share in the quarrel and have wanted for a long time to be friends with your father again, but I was too ashamed and proud to make the first advance. You can tell him so for me, if you like. And if he's willing to let bygones be bygones, tell him I'd like him to come up here with you tonight when he gets home and spend the evening with me."

"Oh, he will come, I know!" cried Prissy joyfully. "He has felt so badly about not being friendly with you, Uncle Richard. I'm as glad as can be."

Prissy ran impulsively around the table and kissed Uncle Richard. He looked up at his tall, girlish niece with a smile of pleasure.

"You're a good girl, Prissy, and a kind-hearted one too, or you'd never have come up here to cook a dinner for a crabbed old uncle who deserved to eat cold dinners for his stubbornness. It made me cross today when folks wished me a Merry Christmas. It seemed like mockery when I hadn't a soul belonging to me to make it merry. But it has brought me happiness already, and I believe it will be a merry year all the way through."

Harper's: Christmas
1896, Edward Penfield

"Indeed it will!" laughed Prissy. "I'm so happy now I could sing. I believe it was an inspiration—my idea of coming up here to cook your dinner for you."

"You must promise to come and cook my Christmas dinner for me every year we live near enough together," said Uncle Richard.

And Prissy promised.

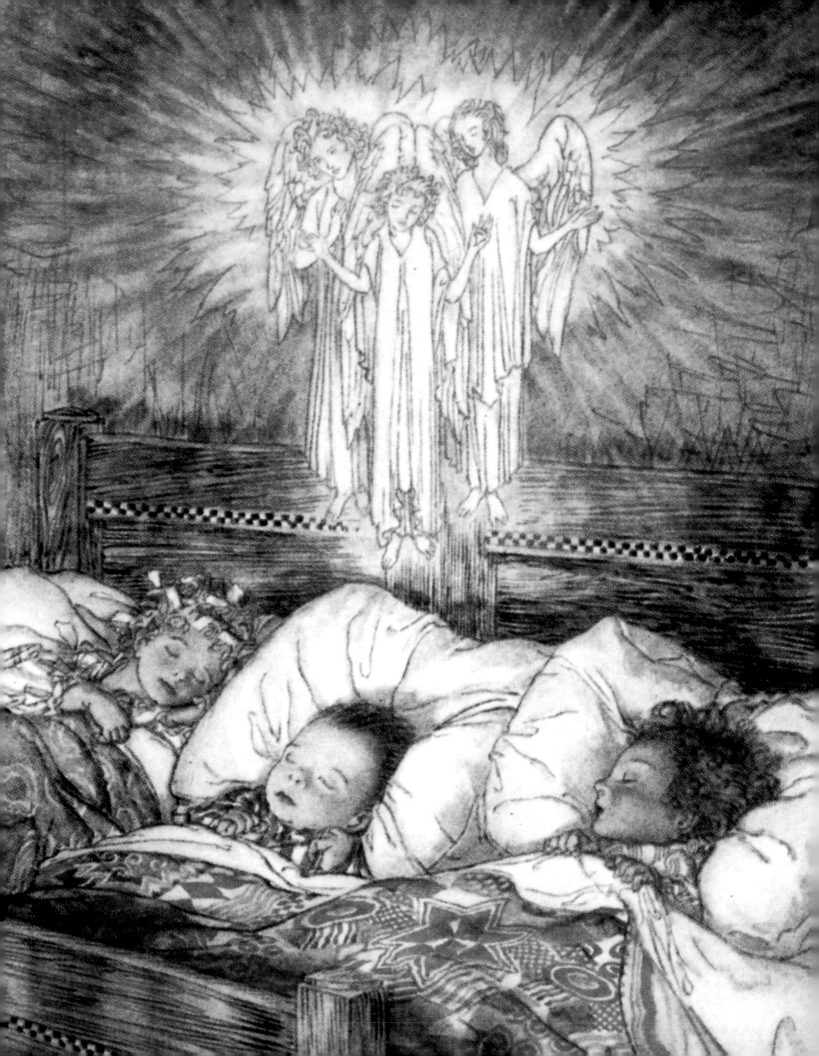

'Twas the Night Before Christmas

By Clement Clarke Moore

'Twas the night before Christmas, when all thro' the house,

Not a creature was stirring, not even a mouse;

The stockings were hung by the chimney with care,

In hopes that St. Nicholas soon would be there;

The children were nestled all snug in their beds,

While visions of sugar plums danc'd in their heads,

And Mama in her 'kerchief, and I in my cap,

Had just settled our brains for a long winter's nap—

When out on the lawn there arose such a clatter,

I sprang from the bed to see what was the matter.

Away to the window I flew like a flash,

Tore open the shutters, and threw up the sash.

The moon on the breast of the new fallen snow,

Gave the lustre of mid-day to objects below;

When, what to my wondering eyes should appear,

But a minature sleigh, and eight tiny rein-deer,

With a little old driver, so lively and quick,

I knew in a moment it must be St. Nick.

The images on pages 48–53 are from the book *The Night Before Christmas*
1931, Arthur Rackham

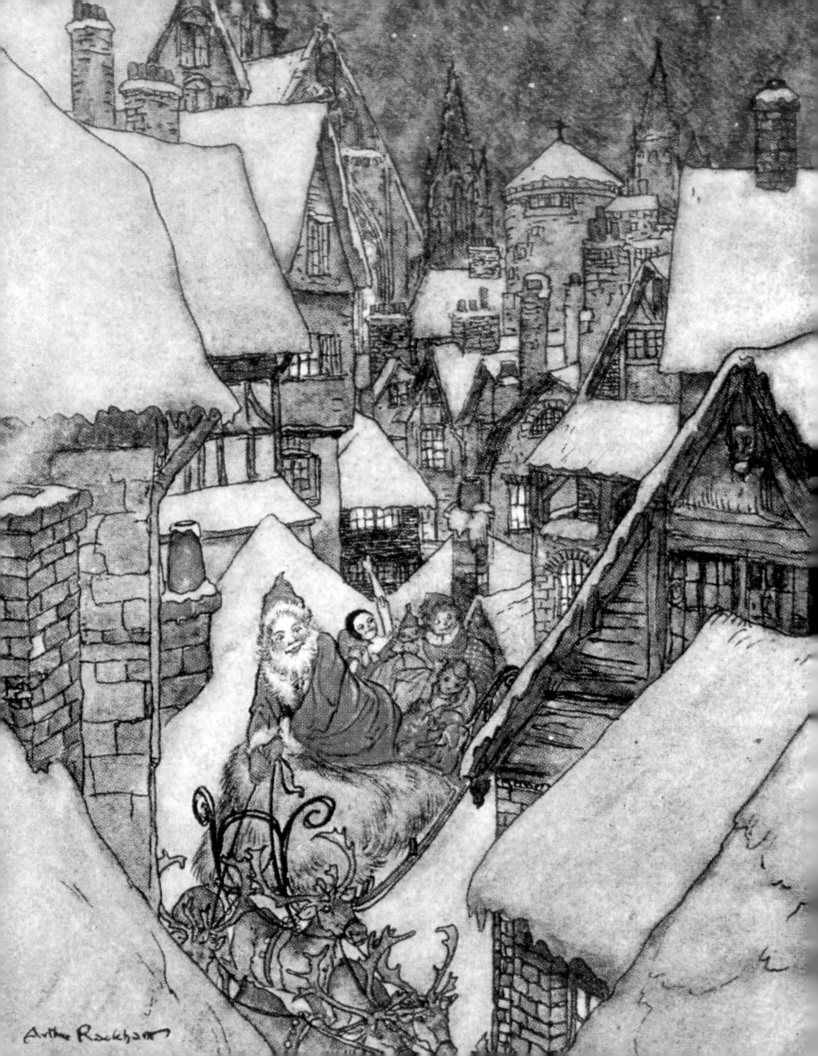

Arthur Rackham

More rapid than eagles his coursers they came,

And he whistled, and shouted, and call'd them by name:

"Now! Dasher, now! Dancer, now! Prancer, and Vixen,

"On! Comet, on! Cupid, on! Dunder and Blixem;

"To the top of the porch! to the top of the wall!

"Now dash away! dash away! dash away all!"

As dry leaves before the wild hurricane fly,

When they meet with an obstacle, mount to the sky;

So up to the house-top the coursers they flew,

With the sleigh full of Toys—and St. Nicholas too:

And then in a twinkling, I heard on the roof

The prancing and pawing of each little hoof.

As I drew in my head, and was turning around,

Down the chimney St. Nicholas came with a bound:

He was dress'd all in fur, from his head to his foot,

And his clothes were all tarnish'd with ashes and soot;

A bundle of toys was flung on his back,

And he look'd like a peddler just opening his pack:

His eyes—how they twinkled! his dimples how merry,

His cheeks were like roses, his nose like a cherry;

His droll little mouth was drawn up like a bow,

And the beard of his chin was as white as the snow;

The stump of a pipe he held tight in his teeth,

And the smoke it encircled his head like a wreath.

He had a broad face, and a little round belly

That shook when he laugh'd, like a bowl full of jelly:

He was chubby and plump, a right jolly old elf,

And I laugh'd when I saw him in spite of myself;

A wink of his eye and a twist of his head

Soon gave me to know I had nothing to dread.

He spoke not a word, but went straight to his work,

And fill'd all the stockings; then turn'd with a jerk,

And laying his finger aside of his nose

And giving a nod, up the chimney he rose.

He sprung to his sleigh, to his team gave a whistle,

And away they all flew, like the down of a thistle:

But I heard him exclaim, ere he drove out of sight—

Happy Christmas to all, and to all a good night.

A Letter from Santa Claus

By Mark Twain

Palace of Saint Nicholas in the Moon
Christmas Morning

My Dear Susy Clemens,

I have received and read all the letters which you and
your little sister have written me . . . I can read your and
your baby sister's jagged and fantastic marks without any
trouble at all. But I had trouble with those letters that you
dictated through your mother and the nurses, for I am a
foreigner and cannot read English writing well. You will
find that I made no mistakes about the things you and
the baby ordered in your own letters—I went down your
chimney at midnight when you were asleep and deliv-
ered them all myself—and kissed both of you, too . . . But
. . . there were . . . one or two small orders I could not fill
because we ran out of stock . . .

There was a word or two in your mama's letter, which . . .
I took to be "a trunk full of doll's clothes." Is that it? I will
call at your kitchen door about nine o'clock this morning
to inquire. But I must not see anybody, and I must not
speak to anybody but you. When the kitchen doorbell
rings, George must be blindfolded and sent to the door.
You must tell George he must walk on tiptoe and not
speak—otherwise he will die someday. Then you must go
up to the nursery and stand on a chair or the nurse's bed
and put your ear to the speaking tube that leads down

Christmas Card (detail)
1912, Mela Koehler

to the kitchen, and when I whistle through it, you must speak in the tube and say, "Welcome, Santa Claus!" Then I will ask whether it was a trunk you ordered or not. If you say it was, I shall ask you what color you want the trunk to be . . . and then you must tell me every single thing in detail that you want the trunk to contain. Then when I say, "Good-bye and a Merry Christmas to my little Susy Clemens," you must say "Good-bye, good old Santa Claus, I thank you very much." Then you must go down into the library and make George close all the doors that open into the main hall, and everybody must keep still for a little while. I will go to the moon and get those things, and in a few minutes I will come down the chimney that belongs to the fireplace that is in the hall—if it is a trunk you want— because I couldn't get such a thing as a trunk down the nursery chimney, you know. . . . If I should leave any snow in the hall, you must tell George to sweep it into the fire- place, for I haven't time to do such things. George must not use a broom but a rag—else he will die someday. . . . If my boot should leave a stain on the marble, George must not holystone it away. Leave it there always in memory of my visit; and whenever you look at it or show it to anybody you must let it remind you to be a good little girl. Whenever you are naughty and someone points to that mark which your good old Santa Claus's boot made on the marble, what will you say, little sweetheart?

Good-bye for a few minutes, till I come down to the world and ring the kitchen doorbell.

Your loving
Santa Claus
Whom people sometimes call "The Man in the Moon"

Rocking Horse with Three Children
1909, Josef Diveky

PART THREE
Songs

Concert of cherubs on Earth
1625–77, Wenceslaus Hollar

The Jefferson R. Burdick Collection

The First Noel

Seventeenth-Century English Carol ❄ Music from W. SANDYS' *Christmas Carols*

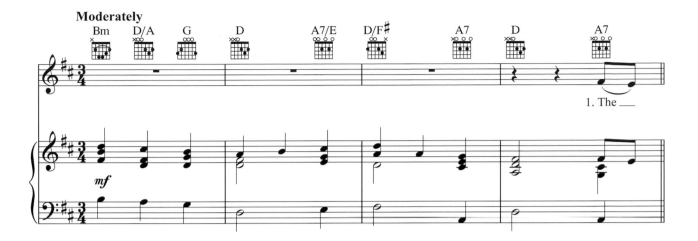

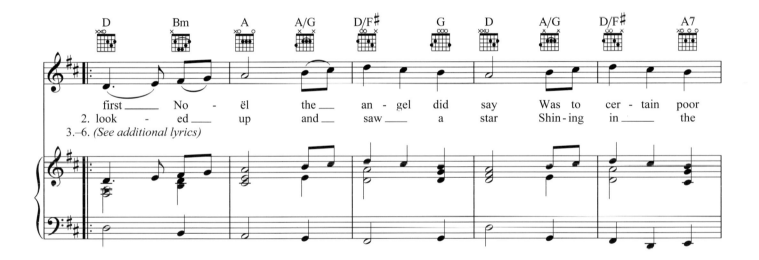

first ___ No - ël the ___ an - gel did say Was to cer - tain poor
2. look - ed ___ up and ___ saw ___ a star Shin - ing in ___ the
3.–6. *(See additional lyrics)*

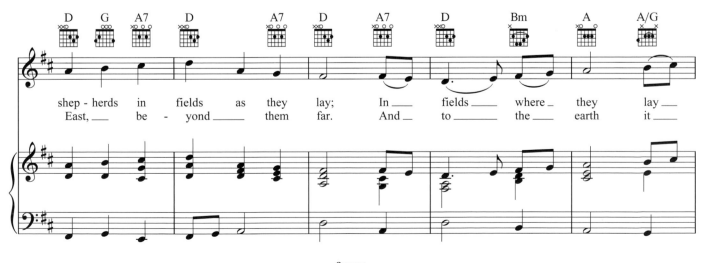

shep - herds in fields as they lay; In ___ fields ___ where they lay ___
East, ___ be - yond ___ them far. And ___ to ___ the ___ earth it ___

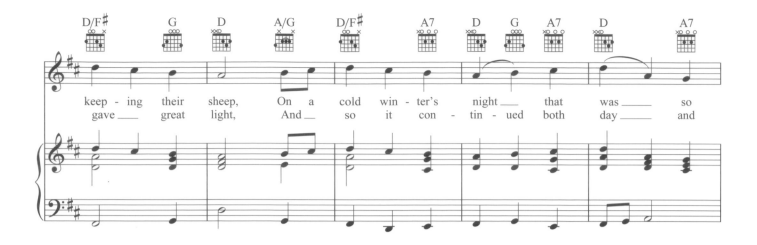

keep - ing their sheep, On a cold win - ter's night ___ that was ___ so
gave ___ great light, And ___ so it con - tin - ued both day ___ and

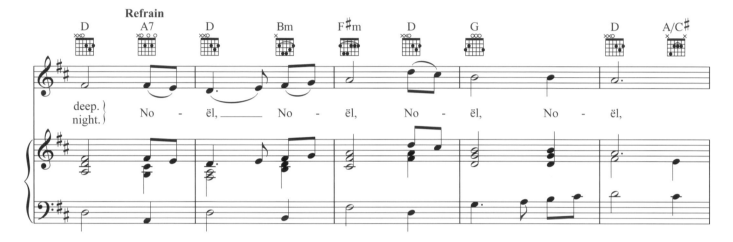

Refrain

deep. }
night. } No - ël, ___ No - ël, No - ël, No - ël,

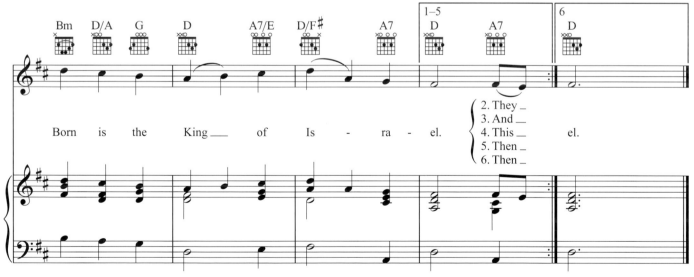

Born is the King ___ of Is - ra - el.

2. They ___
3. And ___
4. This ___ el.
5. Then ___
6. Then ___

Additional Lyrics

3. And by the light of that same star,
 Three wise men came from country far.
 To seek for a King was their intent,
 And to follow the star wherever it went.
 Refrain

4. This star drew nigh to the northwest;
 O'er Bethlehem it took its rest.
 And there it did both stop and stay,
 Right over the place where Jesus lay.
 Refrain

5. Then entered in those wise men three,
 Full rev'rently upon their knee;
 And offered there in His presence,
 Their gold and myrrh and frankincense.
 Refrain

6. Then let us all with one accord
 Sing praises to our heav'nly Lord,
 That hath made heav'n and earth of naught,
 And with His blood mankind hath bought.
 Refrain

Silent Night

Words by JOSEPH MOHR ❄ Translated by JOHN F. YOUNG
Music by FRANZ X. GRUBER

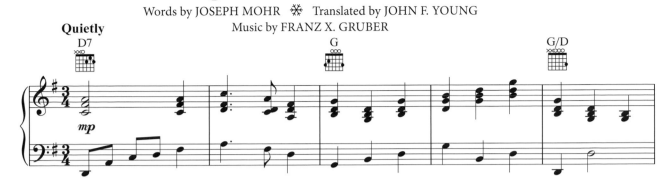

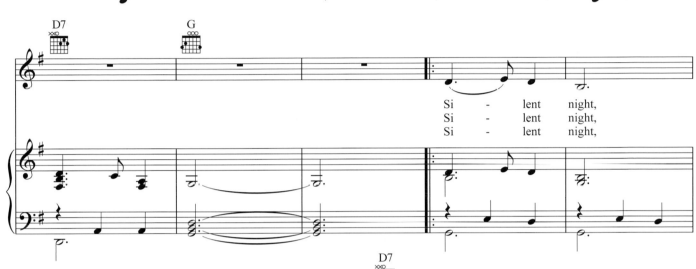

Si - lent night,
Si - lent night,
Si - lent night,

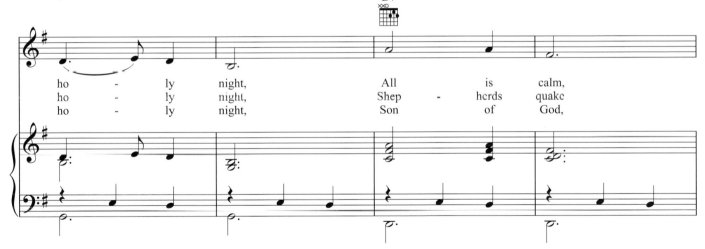

ho - ly night,
ho - ly night,
ho - ly night,

All is calm,
Shep - herds quake
Son of God,

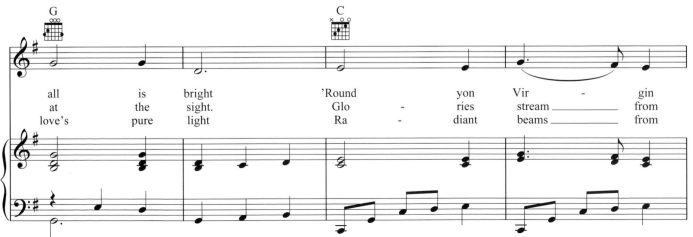

all is bright
at the sight.
love's pure light

'Round yon Vir - gin
Glo - ries stream _____ from
Ra - diant beams _____ from

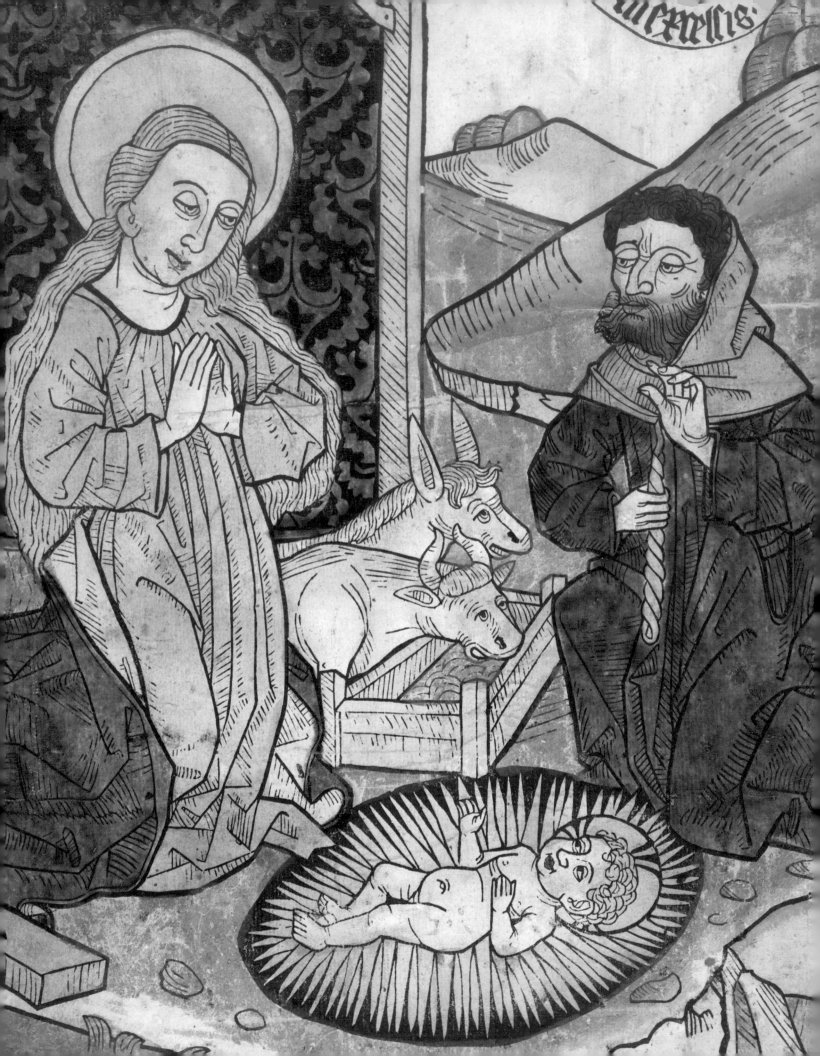

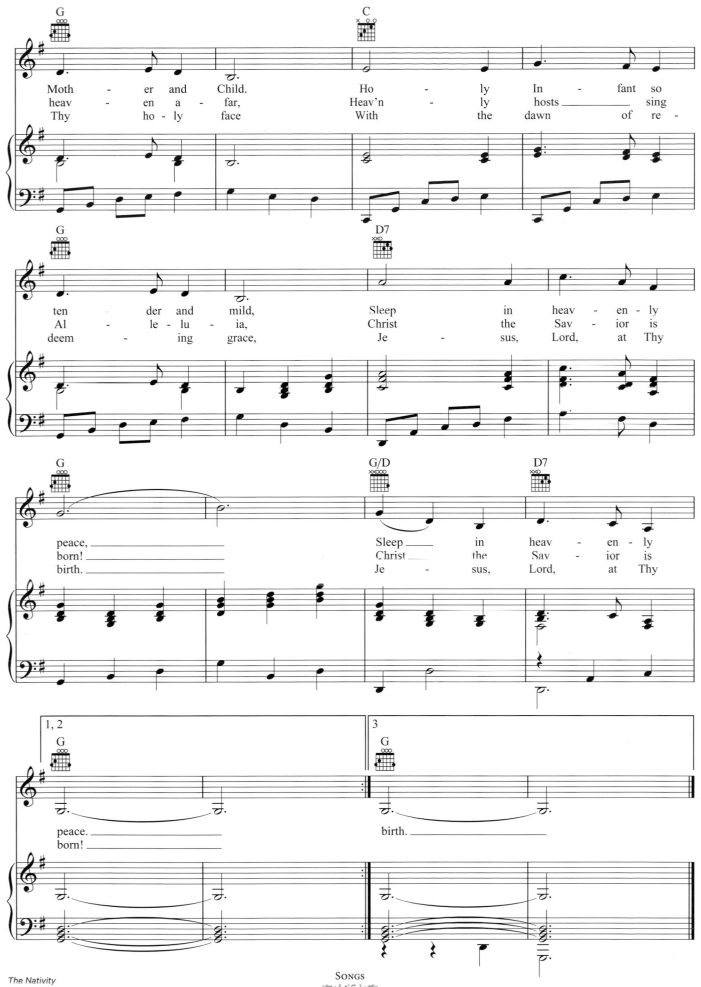

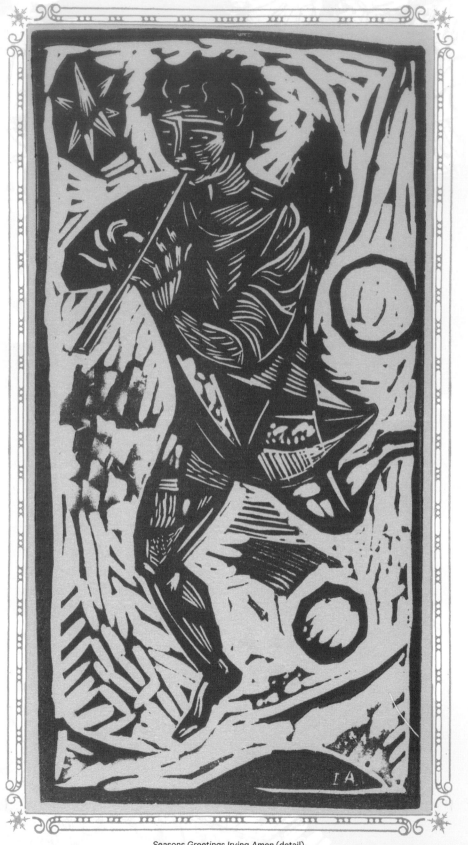

Seasons Greetings Irving Amen (detail)
1954, Irving Amen

O Come, All Ye Faithful

Music by JOHN FRANCIS WADE ✳ Latin Words translated by FREDERICK OAKELEY

Triumphantly

O come, all ye faith - ful,
Sing, all choirs of an - gels,
Yea, Lord, we greet Thee,

joy - ful and tri - um - phant, O come ye, O
sing in ex - ul - ta - tion, O sing all ye
born this hap - py morn - ing, Je - sus, to

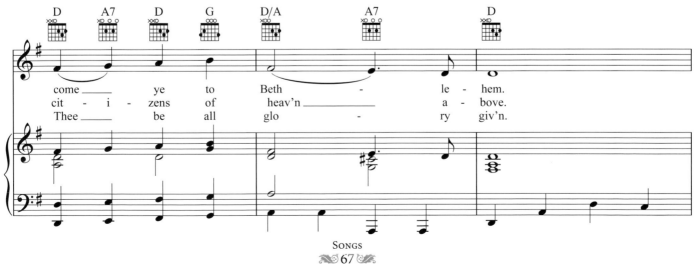

come _____ ye to Beth - le - hem.
cit - i - zens of heav'n _____ a - bove.
Thee _____ be all glo - ry giv'n.

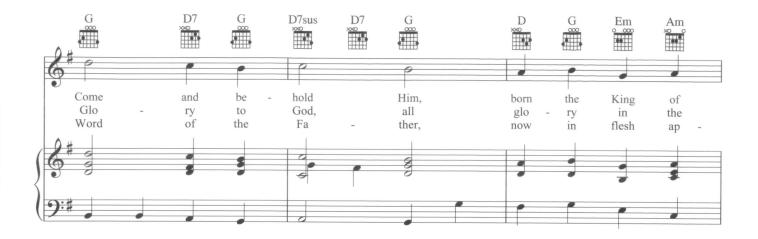

Come ____ and be - hold ____ Him, ____ born the King of
Glo - ry to ____ God, ____ all ____ glo - ry in of the
Word of the ____ Fa - ther, ____ now in flesh ap -

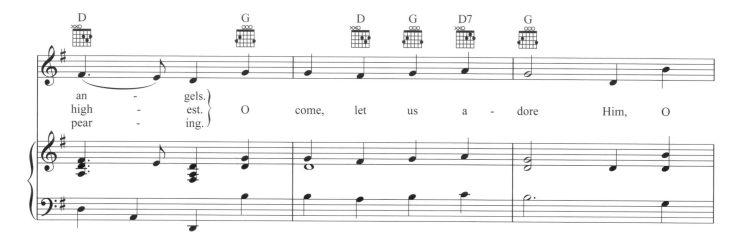

an - ____ gels. ⎫
high - ____ est. ⎬ O come, let us a - dore Him, O
pear - ____ ing. ⎭

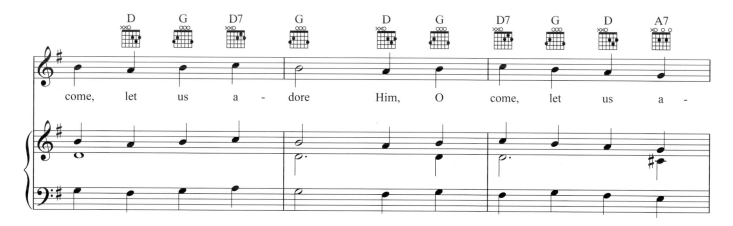

come, let us a - dore Him, O come, let us a -

dore Him, ____ Christ, _____ the Lord!

GOD REST YOU MERRY, GENTLEMEN

Nineteenth-Century English Carol

God rest ye mer - ry, gen - tle - men, let
Beth - le - hem, in Jew - ry this
God our Heav'n - ly Fa - ther a
shep - herds at those tid - ings re -

noth - ing you dis - may, For Je - sus Christ our
bless - ed Babe was born, And laid with - in a
bless - ed an - gel came, And un - to cer - tain
joic - ed much in mind, And left their flocks a -

Sav - ior was born up - on this day, To
man - ger, up - on this bless - ed morn; To
shep - herds brought tid - ings of the same; How
feed - ing in tem - pest, storm and wind; And

Wishing You a Very Merry Christmas and a Happy New Year,
from the New Years 1890 series (N227) issued by Kinney Bros., 1889–90

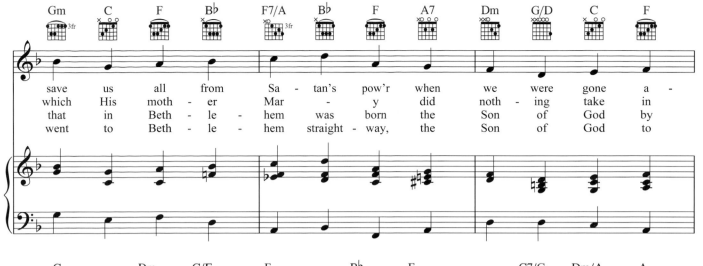

save us all from Sa - tan's pow'r when we were gone a -
which His moth - er Mar - y did noth - ing take in
that in Beth - le - hem was born the Son of God by
went to Beth - le - hem straight - way, the Son of God to

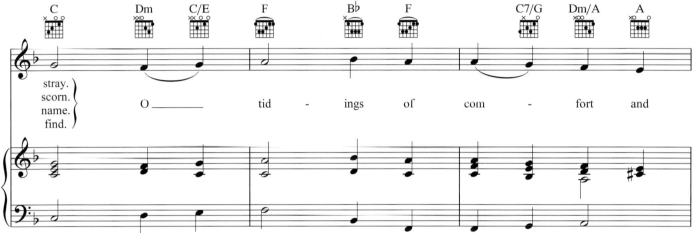

stray.
scorn.
name.
find.

O _____ tid - ings of com - fort and

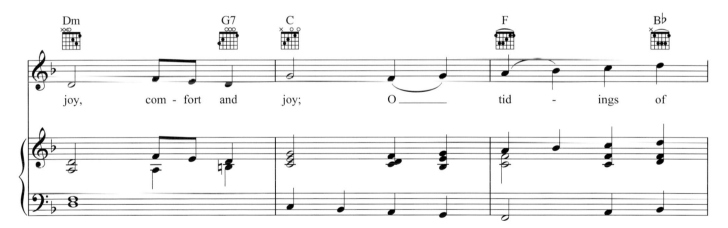

joy, com - fort and joy; O _____ tid - ings of

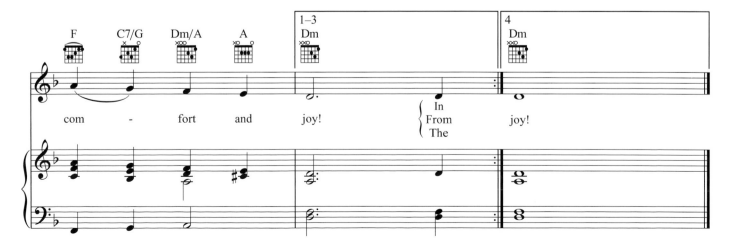

com - fort and joy! In joy!
From
The

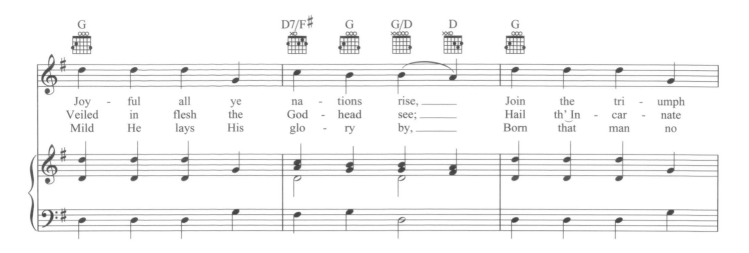

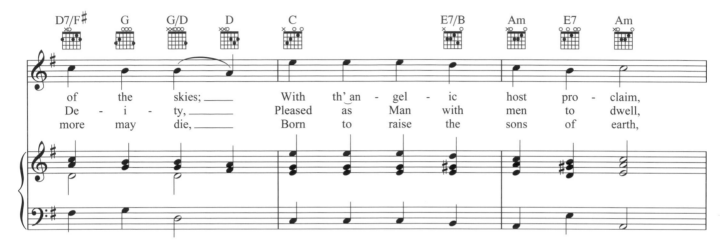

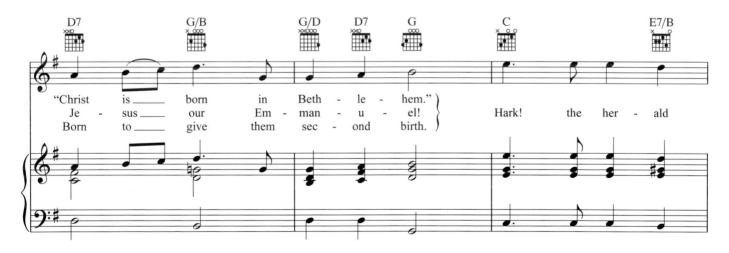

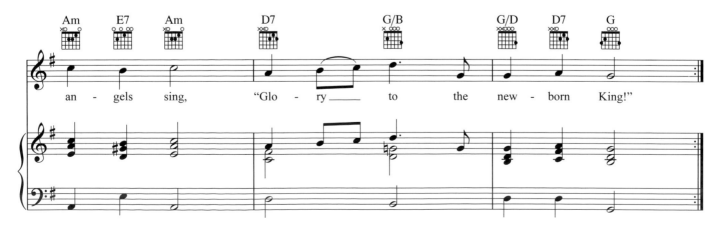

We Wish You a Merry Christmas

Traditional English Carol

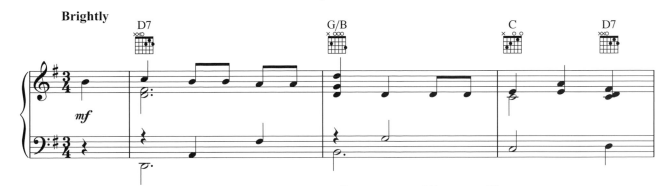

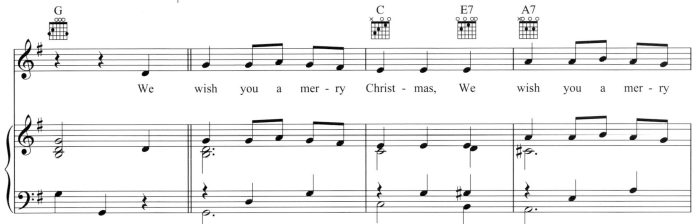

We wish you a merry Christ - mas, We wish you a mer - ry

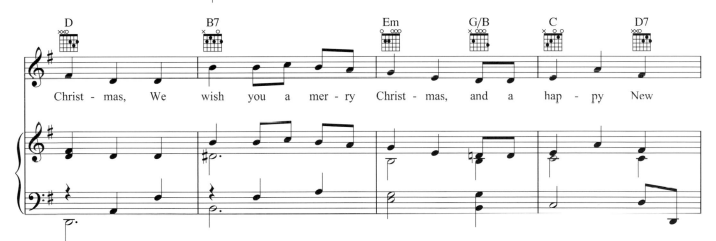

Christ - mas, We wish you a mer - ry Christ - mas, and a hap - py New

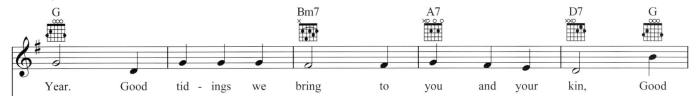

Year. Good tid - ings we bring to you and your kin, Good

Merry Christmas and Happy New Year
from the New Years 1890 series (N227) issued by Kinney Bros., 1889–90

"Trotting Cracks" on the Snow
1858, Louis Maurer

Jingle Bells

Words and Music by J. PIERPONT

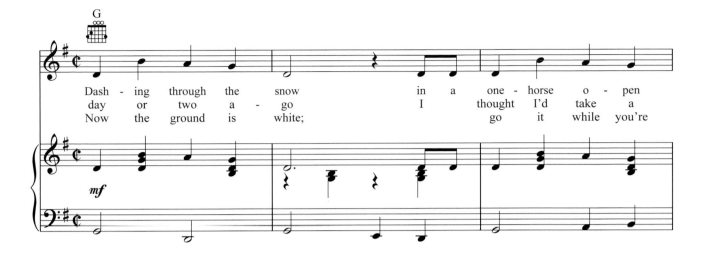

Dash - ing through the snow in a one - horse o - pen
day or two a - go I thought I'd take a
Now the ground is white; go it while you're

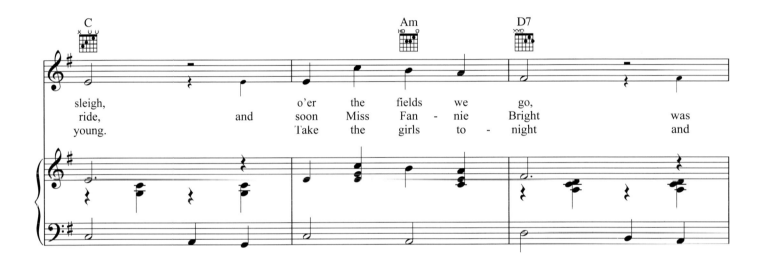

sleigh, o'er the fields we go,
ride, and soon Miss Fan - nie Bright was
young. Take the girls to - night and

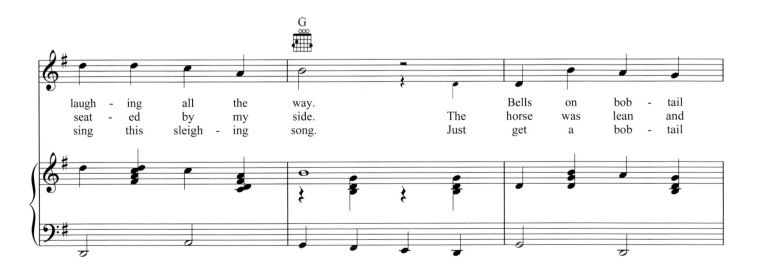

laugh - ing all the way. Bells on bob - tail
seat - ed by my side. The horse was lean and
sing this sleigh - ing song. Just get a bob - tail

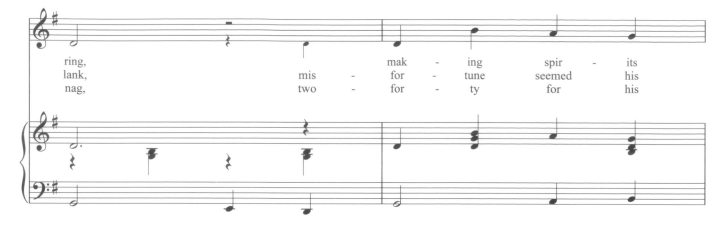

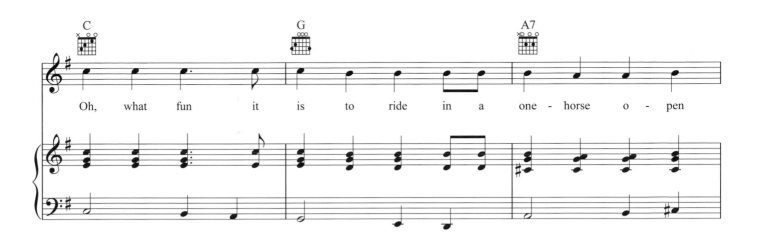

Oh, what fun it is to ride in a one - horse o - pen

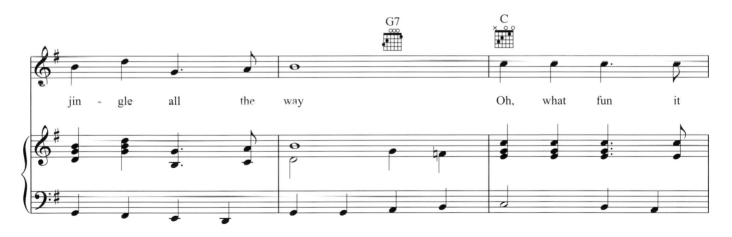

sleigh! Hey! Jin - gle bells, jin - gle bells,

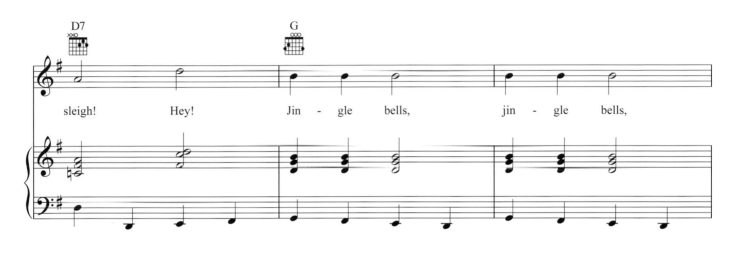

jin - gle all the way Oh, what fun it

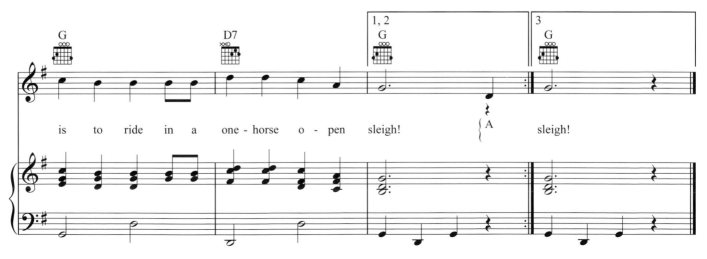

is to ride in a one - horse o - pen sleigh! A sleigh!

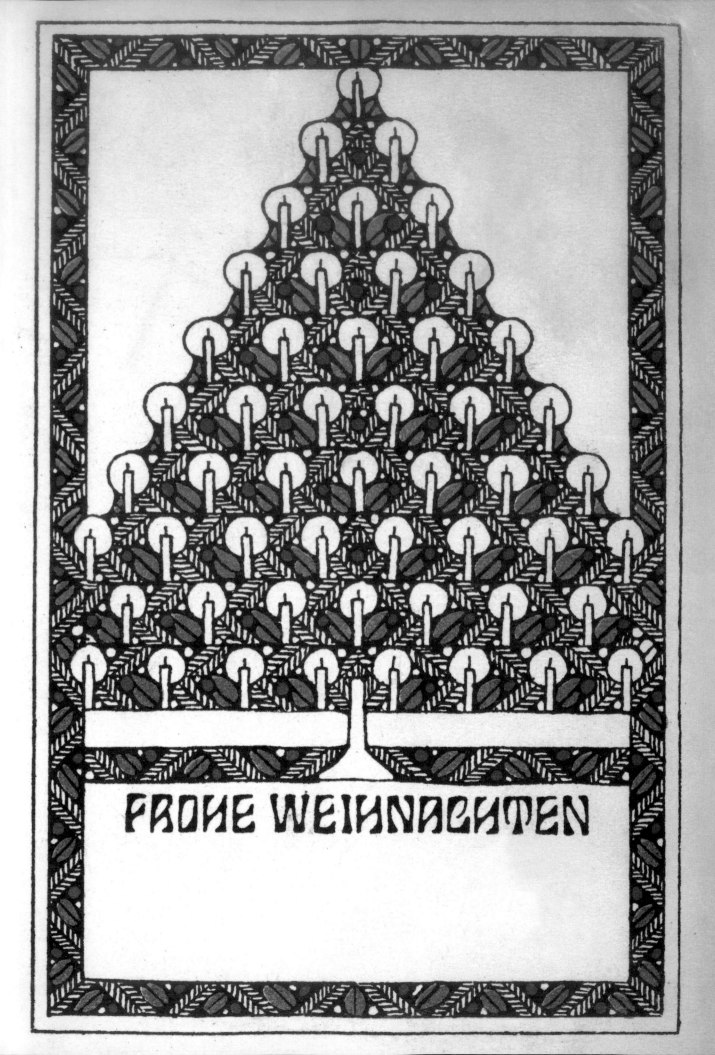

O Christmas Tree

Traditional German Carol

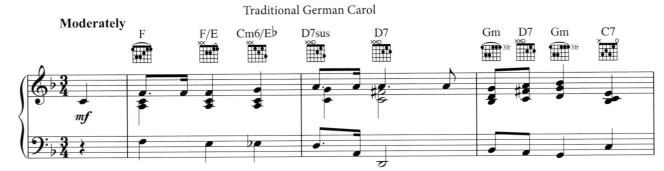

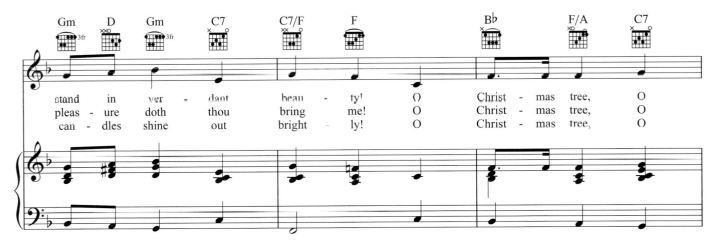

O | Christ - mas tree! | O | Christ - mas tree, | you
Christ - mas tree! | O | Christ - mas tree, | much
Christ - mas tree! | O | Christ - mas tree, | thy

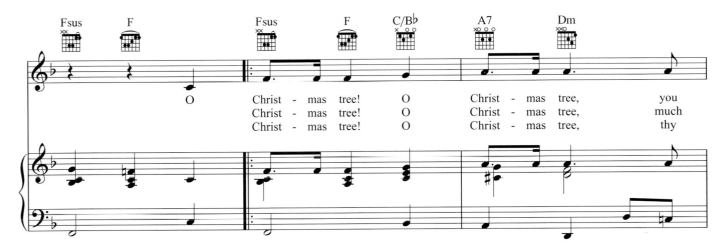

stand | in | ver - dant | beau - ty! | O | Christ - mas tree, | O
pleas - ure | doth | thou | bring | me! | O | Christ - mas tree, | O
can - dles | shine | out | bright - ly! | O | Christ - mas tree, | O

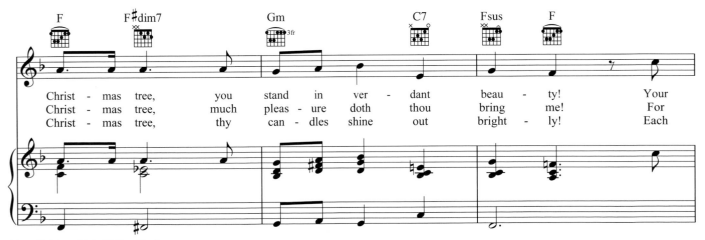

Christ - mas tree, | you | stand | in | ver - dant | beau - ty! | Your
Christ - mas tree, | much | pleas - ure | doth | thou | bring | me! | For
Christ - mas tree, | thy | can - dles | shine | out | bright - ly! | Each

Merry Christmas (Frohe Weihnachten)
1907, Ugo Zovetti

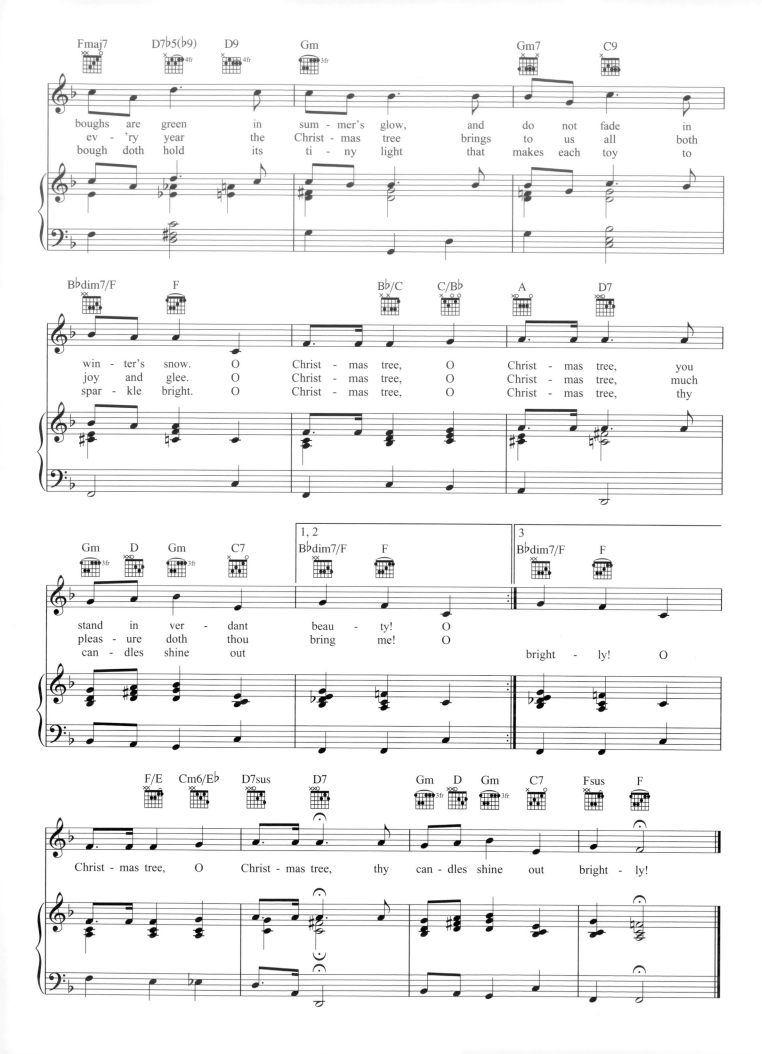

Up on the Housetop

Words and Music by B.R. HANBY

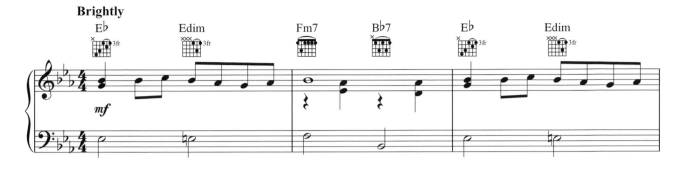

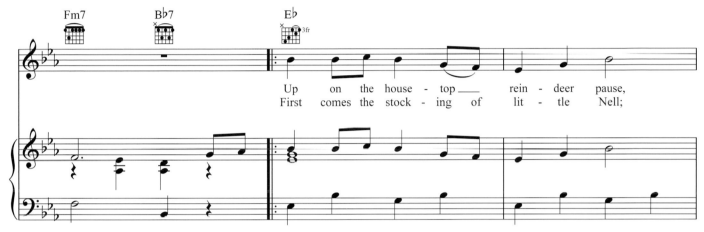

Up on the house-top — rein - deer pause,
First comes the stock - ing of lit - tle Nell;

Out jumps good old San - ta Claus;
Oh, dear good San - ta, fill it well;

Down through the chim - ney with lots of toys,
Give her a dol - ly that laughs and cries,

Reindeer
from the Wild Animals of the World series (N25)
for Allen & Ginter Cigarettes, 1888, George S. Harris & Sons

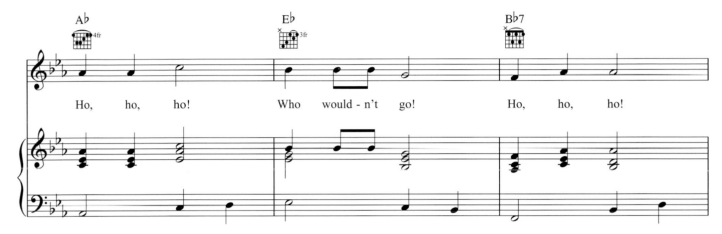

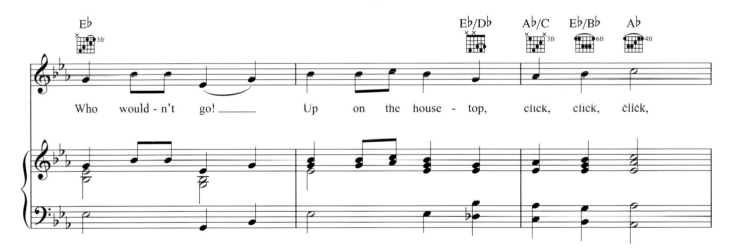

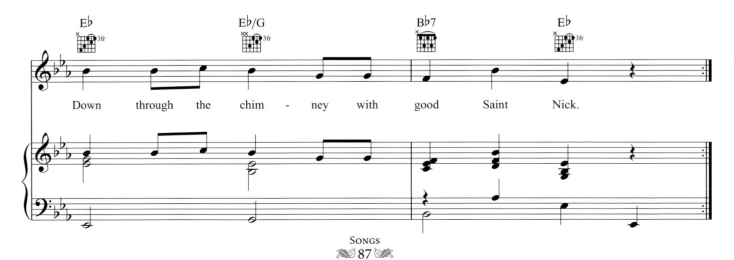

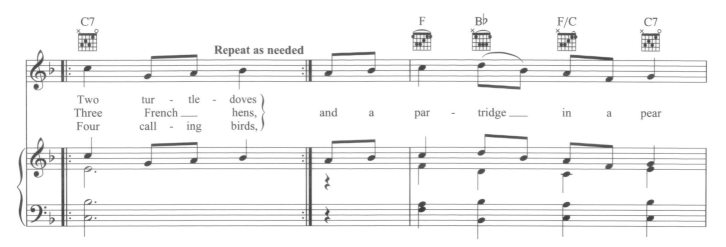

Repeat as needed

Two tur - tle - doves
Three French hens, and a par - tridge in a pear
Four call - ing birds,

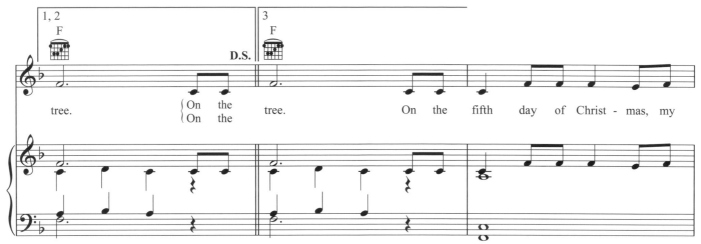

tree. { On the tree. On the fifth day of Christ - mas, my
 { On the

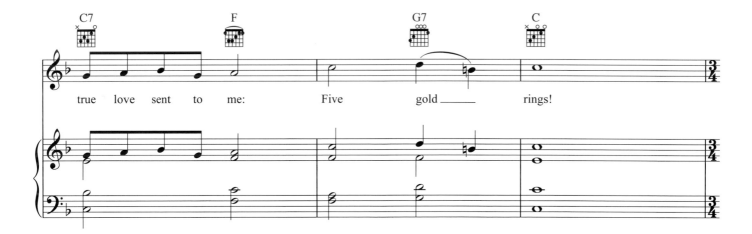

true love sent to me: Five gold _____ rings!

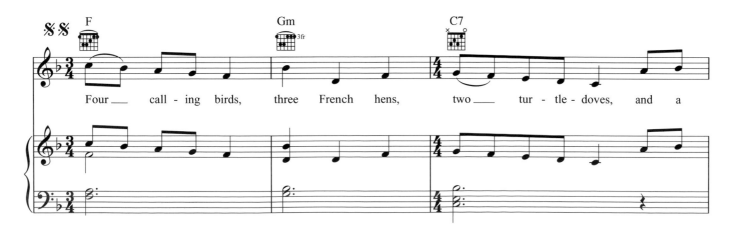

Four ____ call - ing birds, three French hens, two ____ tur - tle - doves, and a

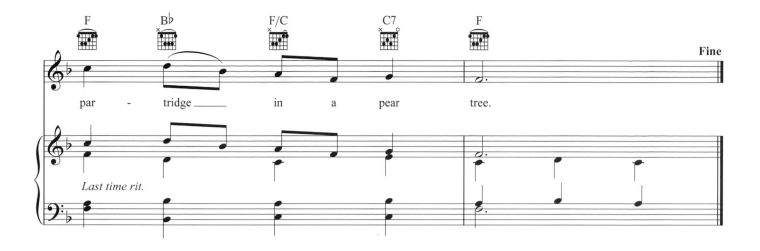

par - tridge _____ in a pear tree.

Last time rit.

Fine

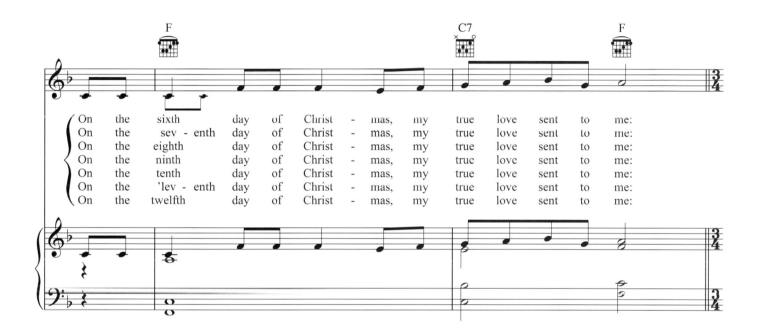

On	the	sixth	day	of	Christ -	mas,	my	true	love	sent	to	me:
On	the	sev - enth	day	of	Christ -	mas,	my	true	love	sent	to	me:
On	the	eighth	day	of	Christ -	mas,	my	true	love	sent	to	me:
On	the	ninth	day	of	Christ -	mas,	my	true	love	sent	to	me:
On	the	tenth	day	of	Christ -	mas,	my	true	love	sent	to	me:
On	the	'lev - enth	day	of	Christ -	mas,	my	true	love	sent	to	me:
On	the	twelfth	day	of	Christ -	mas,	my	true	love	sent	to	me:

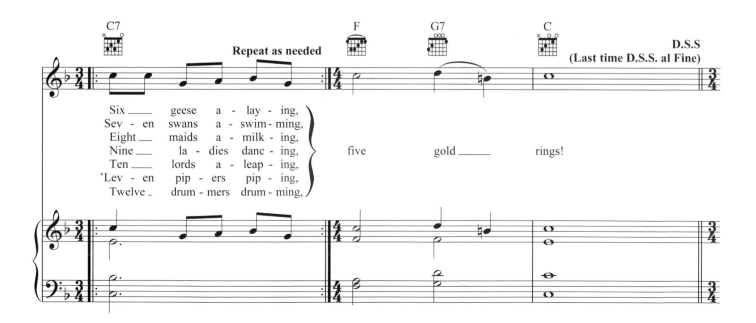

Repeat as needed

D.S.S
(Last time D.S.S. al Fine)

| Six _____ geese a - lay - ing, |
| Sev - en swans a - swim - ming, |
| Eight _____ maids a - milk - ing, |
| Nine _____ la - dies danc - ing, |
| Ten _____ lords a - leap - ing, |
| 'Lev - en pip - ers pip - ing, |
| Twelve _ drum - mers drum - ming, |

five gold _____ rings!

Evening Snow (detail)
1797–1861, Utagawa Hiroshige

PART FOUR

Poems

Joy to the World

By Isaac Watts

Joy to the world, the Lord is come!
Let earth receive her King;
Let every heart prepare Him room,
And Heaven and nature sing,
And Heaven and nature sing,
And Heaven, and Heaven, and nature sing.

Joy to the earth, the Savior reigns!
Let men their songs employ;
While fields and floods, rocks, hills and plains
Repeat the sounding joy,
Repeat the sounding joy,
Repeat, repeat, the sounding joy.

No more let sins and sorrows grow,
Nor thorns infest the ground;
He comes to make His blessings flow
Far as the curse is found,
Far as the curse is found,
Far as, far as, the curse is found,

He rules the world with truth and grace,
And makes the nations prove
The glories of his righteousness,
And wonders of His love.
And wonders of His love.
And wonders, wonders, of His love.

December Songs

By Lee Bennett Hopkins

Having lived for more than three decades in Westchester County, New York, on the Hudson River, I welcomed winter birds that brought joy to the cold, frozen, barren landscape. As for their singing? They had to be hymns to Him.

Outside my window
I see

fluttering-winged doves,
a flock of curious cardinals,
juncos, finches,
red-bellied woodpeckers.

A lone,
ghostlike-feathered
snowy owl swoops by
into this wintered forest,

perches upon
still another leafless,
ice-coated limb.

A sanctuary
of birds

chirping
a cacophonous chorus
of
Christmas hymns
to
Him.

Bird perched on a branch,
bakery card from the Picture Cards
series (D63), issued by the
Manhattan Biscuit Company
Early twentieth century

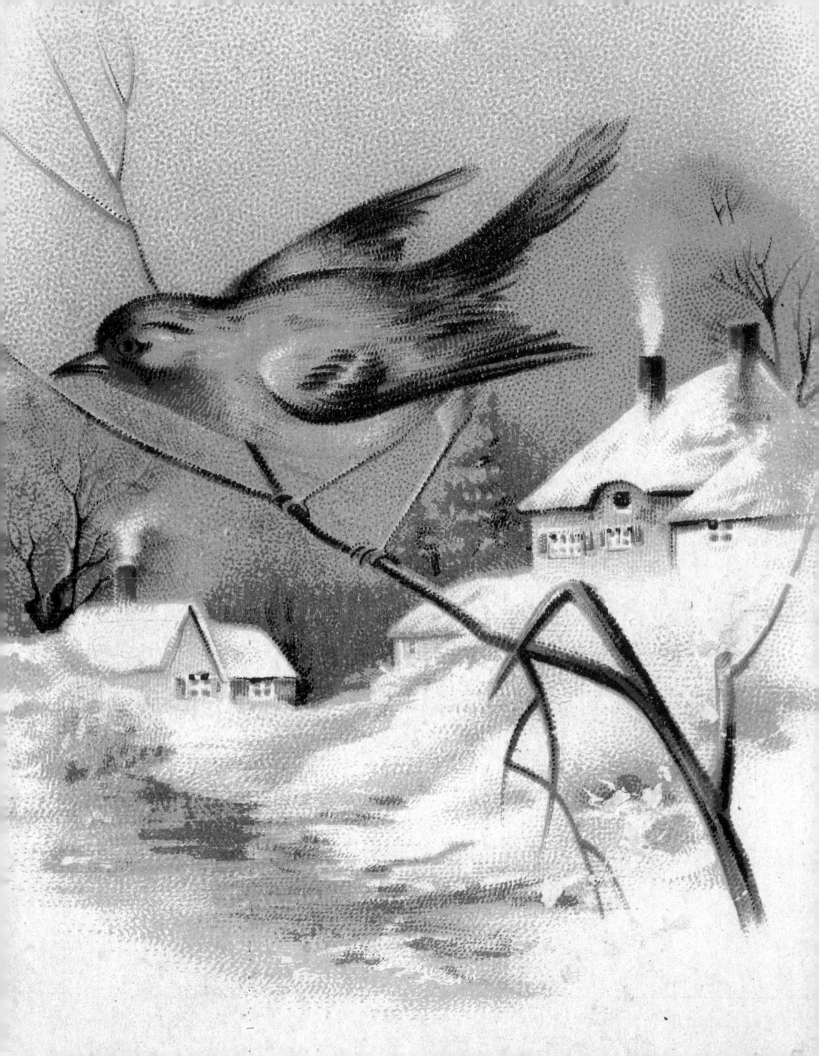

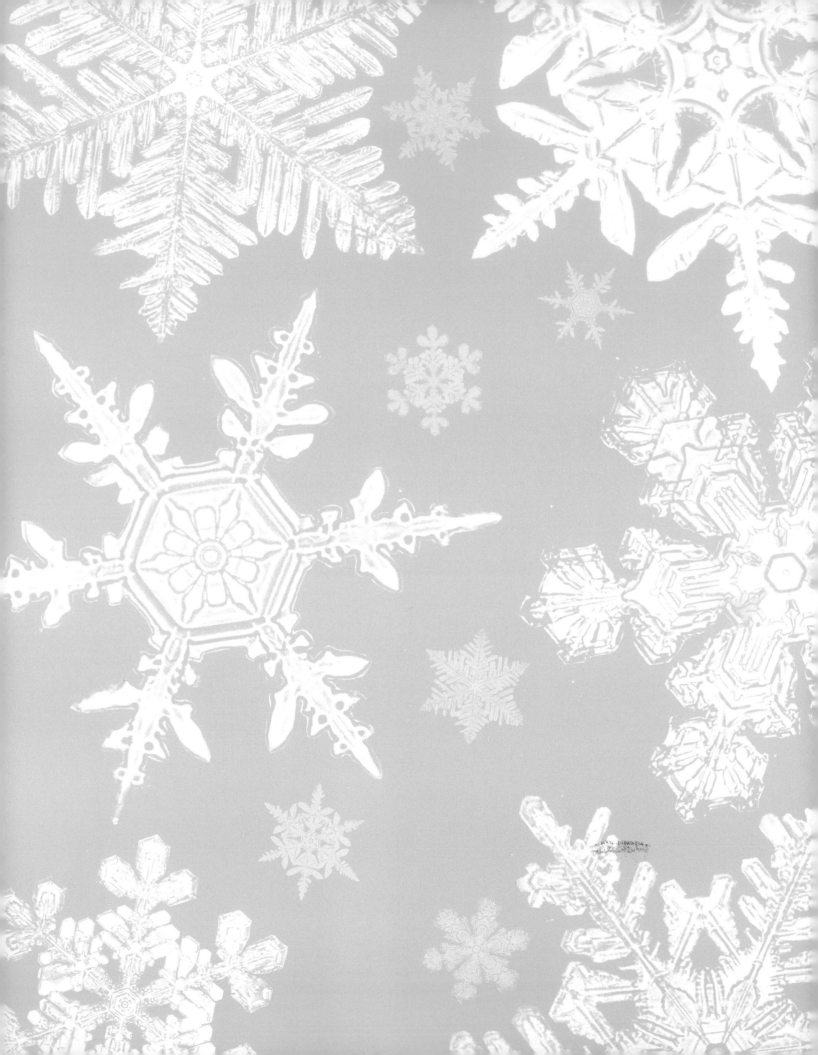

JACK FROST

By Helen Bayley Davis

Someone painted pictures on my
Windowpane last night—
Willow trees with trailing boughs
And flowers, frosty white,
And lovely crystal butterflies;
But when the morning sun
Touched them with its golden beams,
They vanished one by one!

Snow Crystal images
1890s–1920s, Wilson Alwyn Bentley

Winter Morning Poem

By Ogden Nash

Winter is the king of showmen,
Turning tree stumps into snow men
And houses into birthday cakes
And spreading sugar over lakes.

Smooth and clean and frosty white,
The world looks good enough to bite.
That's the season to be young,
Catching snowflakes on your tongue.

Snow is snowy when it's snowing
I'm sorry it's slushy when it's going.

Pink and white flowers (detail)
bakery card from the Picture Cards
series (D63), issued by
The Cleveland Bakery
Early twentieth century

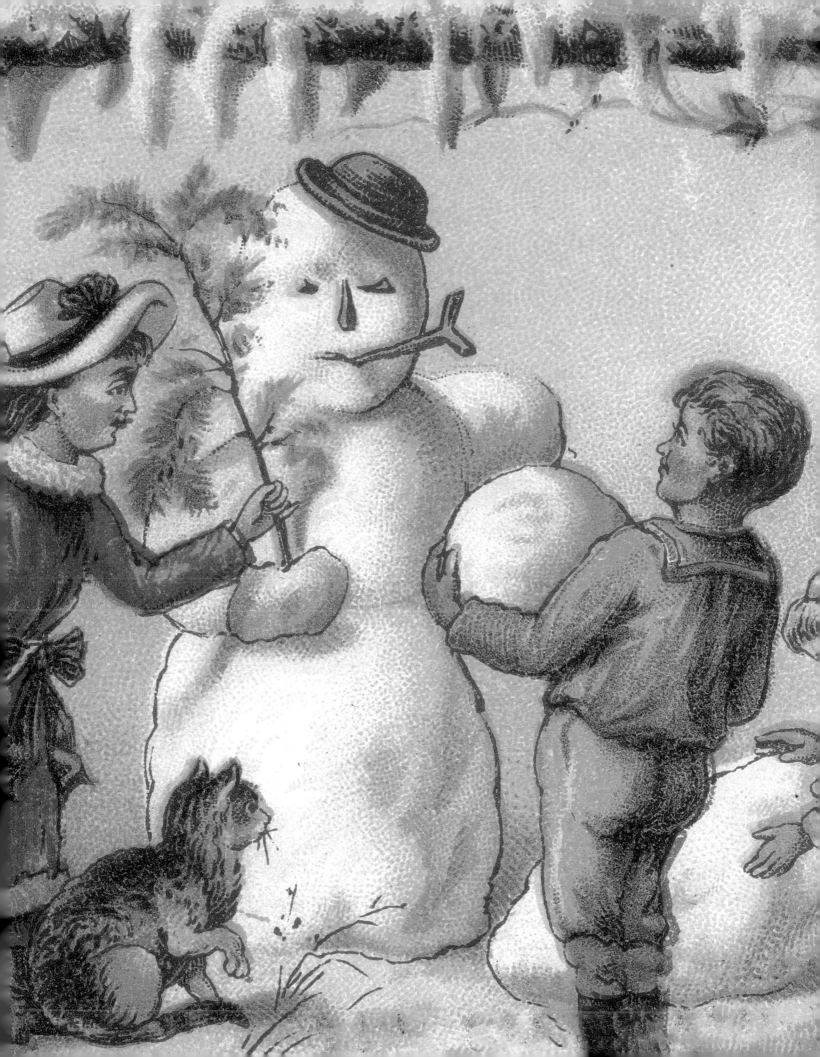

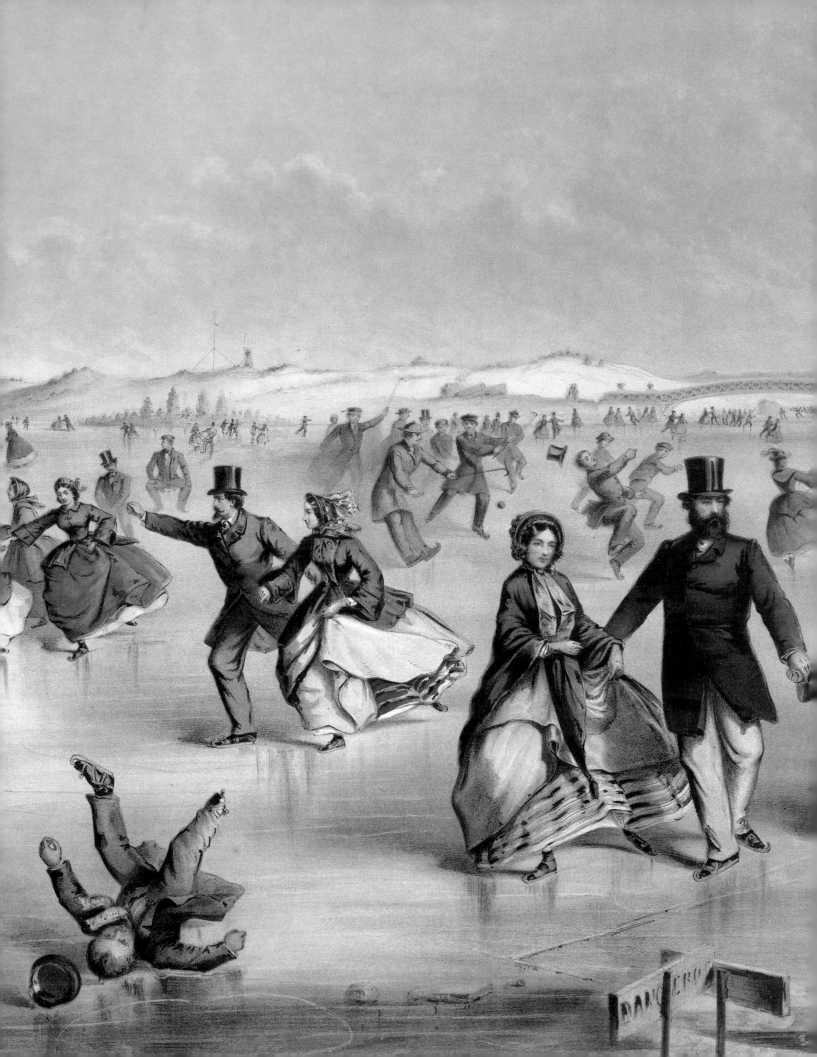

THAW

BY EUNICE TIETJENS

The snow is soft,
and how it squashes!

"Galumph, galumph!"
go my galoshes.

Skating in Central Park, New York (detail)
1861, Winslow Homer

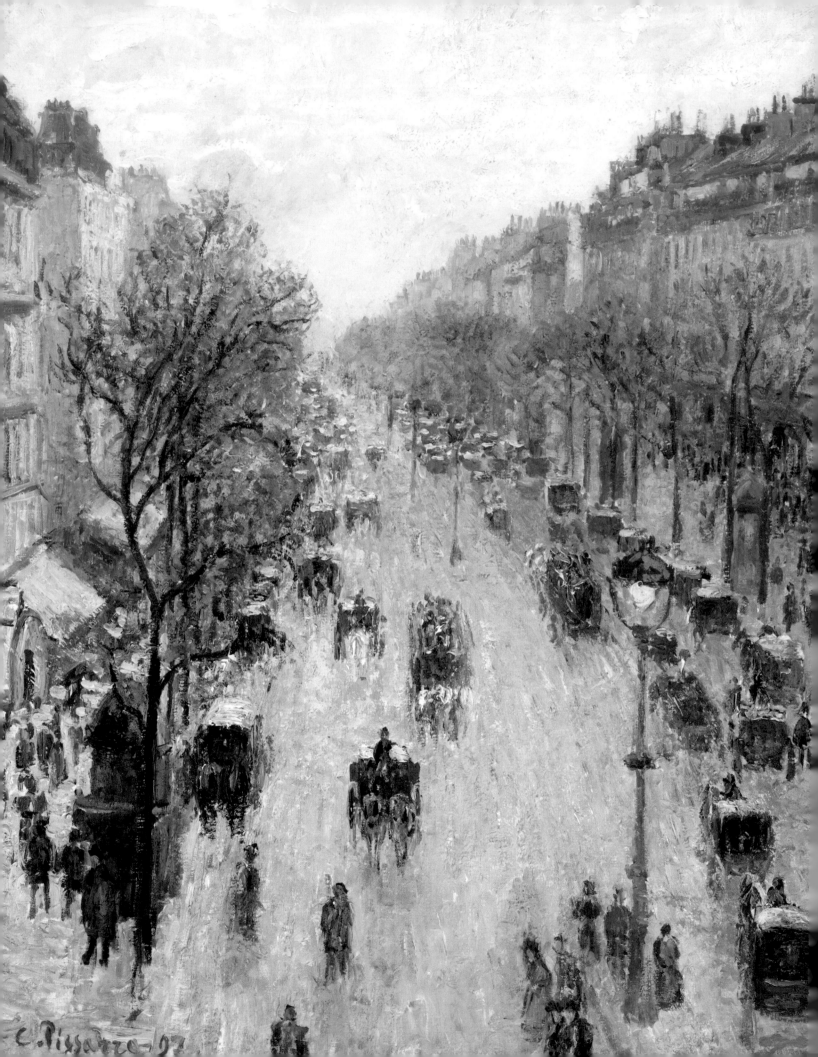

C. Pissarro-97

THE BOULEVARD MONTMARTRE ON A WINTER MORNING

BY MARILYN SINGER

> One December many years ago, I went to Paris. I did much walking and hung out in cafés, bookshops, clubs, and museums, and I spent Christmas Eve staring at the rose windows in Notre Dame! This painting, though set in a different era, spoke to me. It makes me want to visit the magical City of Lights again.

Brisk or blustery,
delivering a dusting of snow or perhaps a blizzard—
the winter does not seem to slow
their bustling along the boulevard,
these restless Parisians,
in carriages, on foot,
in their top hats, top coats,
velvet capes, fanciful furs.
Are they shopping for Christmas gifts
or parading the presents they recently received
before stopping to share (and argue) poetry, painting, song
at their favorite café or music hall?
A portrait of *joie de vivre*,
a study of the darkest season made bright
one cold day in the City of Lights.

The Boulevard Montmartre on a Winter Morning (detail)
1897, Camille Pissarro

CHRISTMAS IS COMING

BY ANONYMOUS

Christmas is coming,
the geese are getting fat,
please put a penny
in the old man's hat.
If you haven't got a penny
a ha'penny will do;
If you haven't got a ha'penny
then God bless you!

Goose
Twentieth century, Xie Zhiliu

Merry Christmas (Fröhliche Weihnachten)
1910, Fritz Zeymer

CHRISTMAS EVE

By Christina Rossetti

Christmas hath darkness
Brighter than the blazing noon,
Christmas hath a chillness
Warmer than the heat of June,
Christmas hath a beauty
Lovelier than the world can show:
For Christmas bringeth Jesus,
Brought for us so low.

Earth, strike up your music,
Birds that sing and bells that ring;
Heaven hath answering music
For all Angels soon to sing:
Earth, put on your whitest
Bridal robe of spotless snow:
For Christmas bringeth Jesus,
Brought for us so low.

BLOW, BLOW, THOU WINTER WIND

By William Shakespeare

Blow, blow, thou winter wind,
Thou art not so unkind
As man's ingratitude;
Thy tooth is not so keen,
Because thou art not seen,
Although thy breath be rude.

Heigh-ho! sing heigh-ho! unto the green holly:
Most friendship is feigning, most loving mere folly:
Then, heigh-ho, the holly!
This life is most jolly!

Freeze, freeze, thou bitter sky,
That dost not bite so nigh
As benefits forgot:
Though thou the waters warp,
Thy sting is not so sharp
As friend remembered not.
Heigh-ho! sing heigh-ho! unto the green holly:
Most friendship is feigning, most loving mere folly:
Then, heigh-ho, the holly!
This life is most jolly!

Scribners: XMAS (detail)
1895, Louis John Rhead

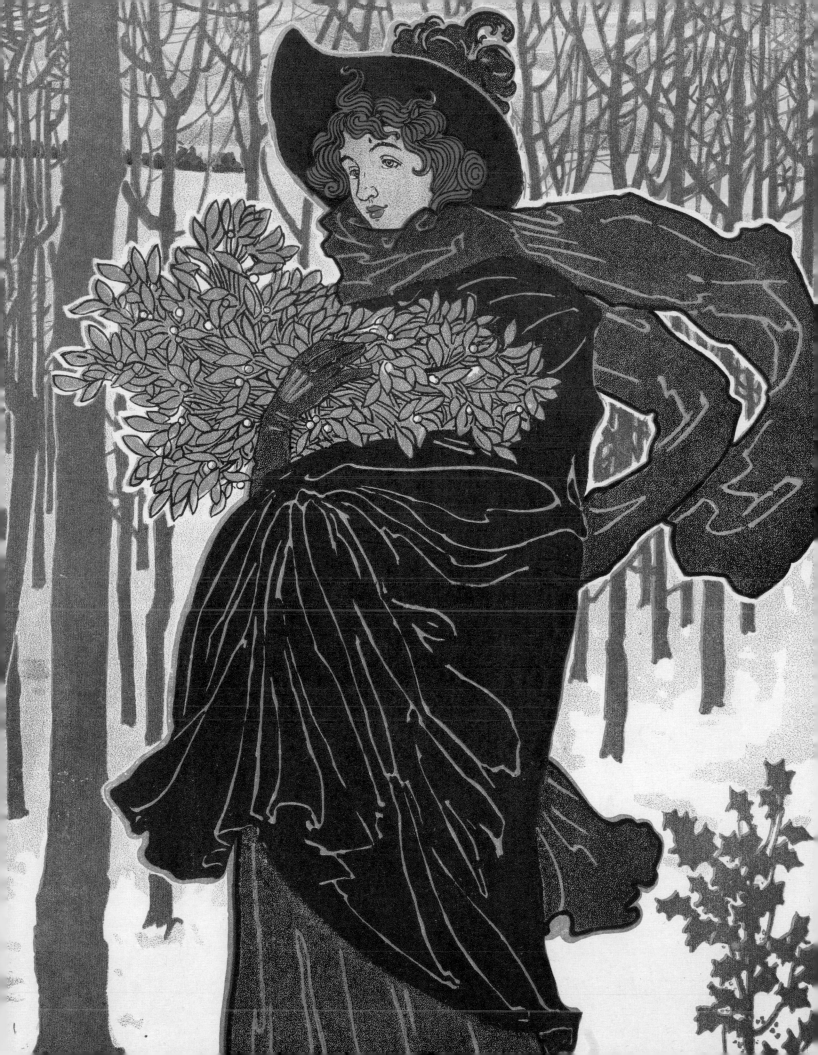

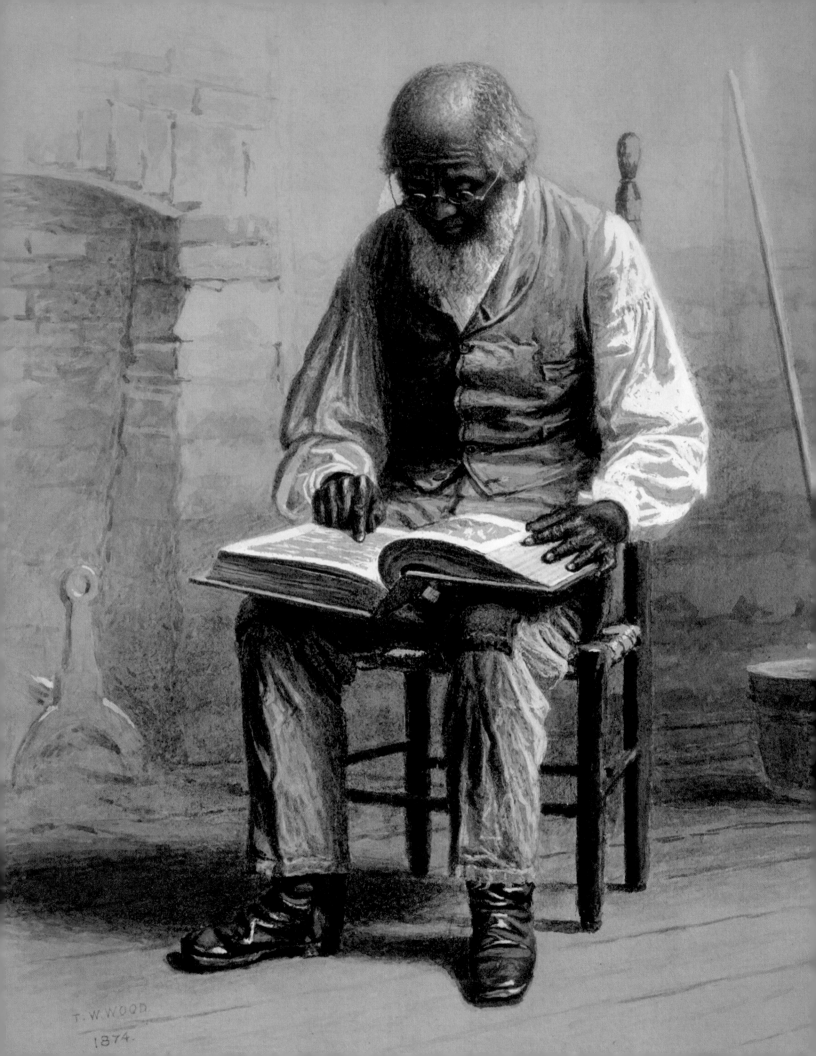

T.W.WOOD
1874.

CHRISTMAS

BY H. P. LOVECRAFT

The cottage hearth beams warm and bright,
The candles gaily glow;
The stars emit a kinder light
Above the drifted snow.

Down from the sky a magic steals
To glad the passing year,
And belfries sing with joyous peals,
For Christmastide is here!

Reading the Scriptures, 1874
Thomas Waterman Wood

On a Day in Gary, Indiana, in the Year of the Moon Walk

By J. Patrick Lewis

> The First Walk on the Moon was July 21, 1969.

On Christmas Day in the year of the Moon walk,
my grandmother's broken mind of misspoken thoughts
swelled with false anger and fierce whimsy, "Sunday
isn't Done Day, boy!" she'd lung-thunder to no one.
"Mice'll wear slippers before that floor's scrubbed."

Or she'd whisper mystery:
"Never paint the black sheep periwinkle blue."
You couldn't count her many cracked nuggets of love.

That was the year I was twelve, and I would have traded
moon rocks in a Mason jar to be a writer, a true spinner
of six-winded tales. How Grandma could have known this
I never knew. But she raised her usual toast that Christmas:
"To every last one of you filthy beggars . . ." and laughed
right along with the rest of us. Then she handed me
the best Christmas present I ever got, in safety-pinned
wax paper, ribboned crazily in Scotch tape.

She pulled me roughly to her and rasped,
"This gem's got a lifetime of words left in it.
Now get to work, you bleeding little Shakespeare."

It was a No. 2 pencil. With Grandma's teeth marks.
There it is now, like a sharp dare sticking out of my
stocking, as it has every Christmas since the moon walk.

Twelve Photographs of the Moon
1863, Austin Augustus Turner

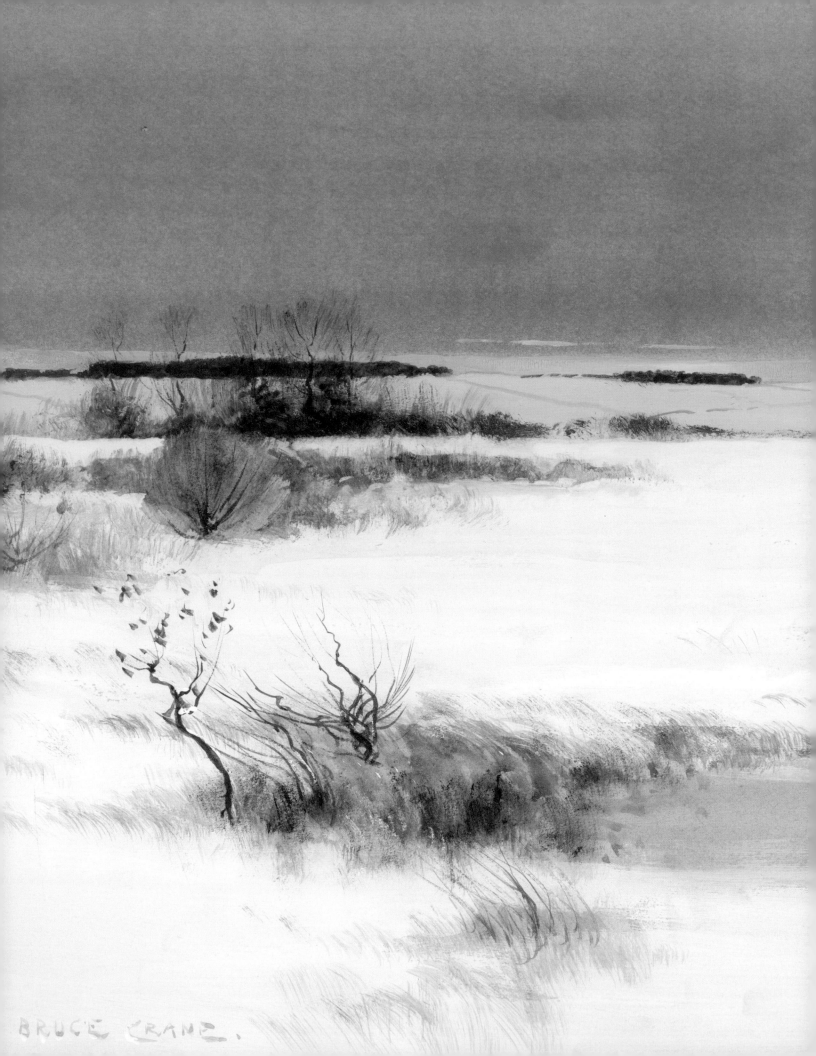

BRUCE CRANE.

Winter-Time

By Robert Louis Stevenson

Late lies the wintry sun a-bed,
A frosty, fiery sleepy-head;
Blinks but an hour or two; and then,
A blood-red orange, sets again.

Before the stars have left the skies,
At morning in the dark I rise;
And shivering in my nakedness,
By the cold candle, bathe and dress.

Close by the jolly fire I sit
To warm my frozen bones a bit;
Or with a reindeer-sled, explore
The colder countries round the door.

When to go out, my nurse doth wrap
Me in my comforter and cap;
The cold wind burns my face, and blows
Its frosty pepper up my nose.

Black are my steps on silver sod;
Thick blows my frosty breath abroad;
And tree and house, and hill and lake,
Are frosted like a wedding-cake.

Snow Scene (detail)
n.d., Bruce Crane

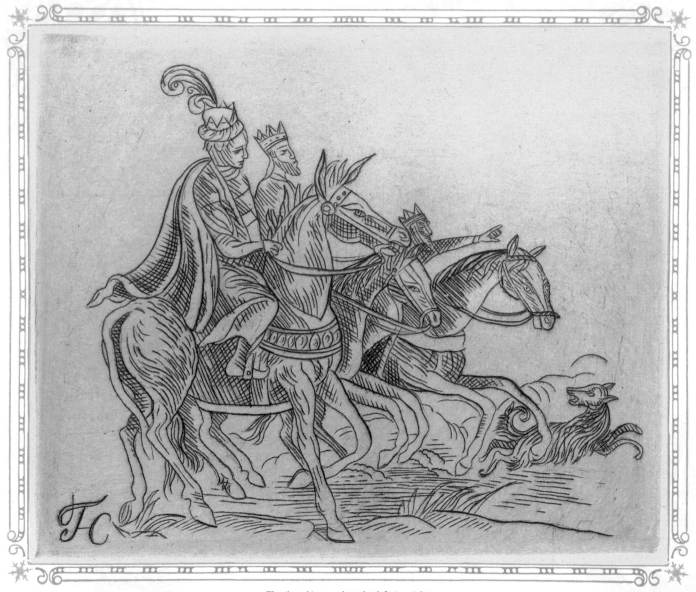

The three kings on horseback facing right,
from a series of prints made as Christmas cards for
Luis García Lecuona
1954–57, Federico Cantù

Christmas in Summer

By Alma Flor Ada

Los Reyes Magos (The Magi) have been very much loved by Hispanic children as the bearer of gifts on January 6, the day Melchior, Gaspar, and Balthazar brought gifts to Jesus in the stable. In South American folklore artwork, they are typically shown arriving on a camel, a horse, and an elephant, suggesting they came from three different faraway lands.

Books and movies,
photos and cards
all show Christmas
dressed in white.

Yet where I'm from,
south of the Equator,
Christmas is often
a day at the beach.

By January 6
summer vacation
has just begun.
Lots of time
for all the gifts
brought from afar
on a camel,
a white horse,
an elephant's back
by *Los Reyes Magos,*
the Three Wise Men.

No ice, no snow,
no windy storm,
Christmas, our time
to enjoy the sun!

LITTLE TREE

By E .E. CUMMINGS

little tree
little silent Christmas tree
you are so little
you are more like a flower

who found you in the green forest
and were you very sorry to come away?
see i will comfort you
because you smell so sweetly

i will kiss your cool bark
and hug you safe and tight
just as your mother would,
only don't be afraid

look the spangles
that sleep all the year in a dark box
dreaming of being taken out and allowed to shine,
the balls the chains red and gold the fluffy threads,

put up your little arms
and i'll give them all to you to hold.
every finger shall have its ring
and there won't be a single place dark or unhappy

then when you're quite dressed
you'll stand in the window for everyone to see
and how they'll stare!
oh but you'll be very proud

and my little sister and i will take hands
and looking up at our beautiful tree
we'll dance and sing
"Noel Noel"

Santa Looking at a Bird in a Tree
ca. 1952, Saul Steinberg

It is the time of rain and snow

By Izumi Shikibu

It is the time of rain and snow
I spend sleepless nights
And watch the frost
Frail as your love
Gathers in the dawn.

Asukayama in Evening Snow (detail)
ca. 1838, Utagawa Hiroshige

ARE YOU READY FOR CHRISTMAS?

BY NAOMI SHIHAB NYE

My father was a Palestinian born into a Muslim family in Jerusalem. As a child he was fascinated by Christian pilgrims arriving in the Holy City particularly at Christmas and Easter, gathering in churches to pray, sing, and hike with flickering candles to Bethlehem or other holy sites. He asked his devout mother if he could join them. She allowed him to do so, stressing the connections between people and religions. I lived in Jerusalem as a teen and saw some of the same lovely rituals my father remembered. The commercialism of Christmas in the United States has always confounded me though—expectations, early decorations (but I love the illuminations), and general patter exchanged, as in my poem's title. It's always the hardest time of year for me. Writing this poem helped me understand why.

What does "ready" mean?

Boxes with bows, shining paper neatly trimmed
and taped, a heap of planning.

I always worry nothing I give
is enough. Wishing to share a mood,

breeze, hope, a better idea . . . I want the kids
in Gaza to have electricity all day long

and the kids in Bethlehem to feel peace with
their neighbors and no walls blocking movements,

no kids sad about houses crushed or
parents disappeared. I want no trees uprooted.

O little town of Bethlehem, might the year end
on a high note of joy?

Could people in hospitals
come bounding forth, suddenly well,

and no one feel abandoned? Everyone surprised
by love. A man said,

Whatever you are planning to give,
give twice as much.

That's what I want.
Then I will be ready.

CHRISTMAS IS COMING!
128

Jérusalem, Beit-Lehem, Vue générale (detail)
1854, Auguste Salzmann

CHRISTMAS LAUGHTER

By Nikki Giovanni

My family is very small
Eleven of us
Three are over 80
Three are over 60
Three are over 50
Two of us are sons

Come Labor Day the quilts
are taken from the clean white sheets
in which they summered

We seldom have reason
and need no excuse
to polish the good silver
wash the tall stemmed glasses
and invite one another
into our homes

We win at Bid Whist
and lose at Canasta
and eat the lightest miniature Parker House rolls
and the world's best
five-cheese macaroni and cheese

I grill the meat
Mommy boils the beans

Come first snow the apple cider
with nutmeg . . . cloves . . . cinnamon . . .
and just a hint of ginger
brews every game day and night

We have no problem
luring
Santa Claus
down
our chimney

He can't resist
The laughter

Quilt, Star of Bethlehem pattern variation
ca. 1837–50, Ellen Morton Littlejohn and Margaret Morton Bibb

CHRISTMAS CHERRIES

BY JANET S. WONG

My father, over eighty years old now, still loves to pick cherries
fresh off the tree. When I saw him last summer, he gave me a huge
bag of cherries—for three merry days of cherry eating that made
me feel like a little girl again.

Every year
on the hottest day in June
we drive to the U-Pick farm.
Mom's rule is
you've got to eat
as much as you pay for,
so we always waddle away
sick of cherries
for at least a month after.

At home
we pack the fruit tight in jars
and fill the small gaps
with sugar and wine.
Six months later,
it's time for cherries
on Christmas Eve.
We pop them in our mouths,
these little woozy bits of summer,
while people sing
about snow on TV.

[Grove of Cherry Trees] (detail)
1900, Adolf de Meyer

PART FIVE

Recipes

No-Bake Goat Cheese Cheesecake with Gingered Pears

By Yvette van Boven

Makes one 9-inch (23-cm) cheesecake

FOR THE CRUST

- 7 ounces (200 g) wholemeal cookies (such as digestives or crisp oatmeal cookies)
- 3 tablespoons (30 g) candied ginger, roughly chopped
- ⅓ cup (75 g) unsalted butter, melted

FOR THE FILLING

- 4 Bartlett pears, peeled
- 3 sprigs thyme
- 1-inch (2.5-cm) piece fresh ginger, sliced
- 5 cardamom pods, crushed
- 3 lemons
- 1¼ cups (250 g) granulated sugar
- ½ cup (120 ml) heavy cream
- 4 cups (460 g) soft goat cheese, crumbled
- ¾ cup (180 ml) crème fraîche
- Salt

1. Make the crust: In a food processor, grind the cookies with the candied ginger until they become coarse crumbs. (Alternatively, place the cookies in a sturdy plastic bag and crush them with a rolling pin. Finely chop the ginger with a sharp knife, then combine with the cookie crumbs.) Add the melted butter and process until the crumbs are coated. Transfer the mixture to a 9-inch (23-cm) pie pan and press to cover the bottom and sides evenly. Refrigerate the crust for 30 minutes to firm up.

2. Make the filling: Place the pears, thyme sprigs, ginger, cardamom, the juice of one lemon, and ½ cup (100 g) of the sugar in a pot. Add water to cover the pears and bring to a boil over high heat. Reduce the heat to medium and simmer the pears 30 minutes or until just tender. Leave the pears to cool in the liquid.

3. Beat the heavy cream in a stand mixer until it forms stiff peaks.

4. In a food processor, combine the goat cheese, crème fraîche, remaining ¾ cup (150 g) sugar, a pinch of salt, and the juice of a lemon until smooth. Transfer to a large bowl and fold in the whipped cream.

5. Remove the pears from the poaching liquid and slice thinly. Nest half of the slices evenly in the bottom of the crust (set the other slices aside). Spoon the goat cheese mixture on top and smooth with a spatula. Refrigerate at least 4 hours to set.

6. Take the cheesecake out of the fridge at least 1 hour before serving. Decorate the set cheesecake with the remaining sliced pears. Serve.

Note: This cake keeps well in the fridge. You could easily keep it (well covered!) for up to five days.

S. Roesen
1855

Rum Raisin Semifreddo with Tangerine Caramel and Hazelnut Brittle

By Yotam Ottolenghi

Serves 8

FOR THE SEMIFREDDO

- ¾ cup (110 g) raisins
- ½ cup (120 ml) dark rum or ½ cup (120 ml) orange juice
- 6 eggs, separated
- ¾ teaspoon vanilla bean paste
- ½ cup plus 3 tablespoons (135 g) granulated sugar
- 1¼ cups (300 ml) heavy cream
- 1 cup (230 g) mascarpone
- 1 tablespoon tangerine zest (from 2 to 3 tangerines)

FOR THE HAZELNUT BRITTLE

- ⅓ cup (75 g) granulated sugar
- ⅔ cup (75 g) blanched hazelnuts, very well toasted
- Flaky sea salt

FOR THE TANGERINE CARAMEL

- ⅓ cup (75 g) granulated sugar
- ⅓ cup (75 ml) tangerine juice (from 3 to 4 tangerines)
- ¼ teaspoon vanilla bean paste

Soak the raisins in rum the night before starting the semifreddo if you can; they will be juicier and plumper for it. The semifreddo needs to set overnight, so you'll need to start the raisins two days before. The hazelnut brittle can be made a day ahead and kept in an airtight container. If you like a boozy dessert, feel free to add another tablespoon of rum to the semifreddo mix.

1. Make the semifreddo: In a small saucepan, heat the raisins and rum over medium-high heat until the rum is hot. Remove from the heat and leave the raisins to cool in the rum. Transfer to a sealed jar and refrigerate overnight, or at least a few hours at room temperature.

2. Line a 2-quart (2-L) pudding bowl with enough plastic wrap that it hangs over the sides.

3. Combine the egg yolks, vanilla bean paste, and ½ cup (100 g) of the sugar in the bowl of a stand mixer with the whisk attachment in place. Whisk for 3 to 4 minutes, or until pale, fluffy, and roughly doubled in volume. Decrease the speed to low, add the cream and mascarpone, and whisk until smooth and incorporated, about 1 minute. Increase the speed and whip for another 2 minutes, until thickened. Transfer to a large bowl and set aside. Thoroughly clean and dry the bowl of the stand mixer and the whisk attachment to be used again.

4. Weigh 3½ ounces (100 g) of the egg whites in the clean bowl of the stand mixer with the whisk attachment in place (the remaining egg whites can be used in another recipe). Whip the egg whites on low, increasing to high and adding the remaining 3 tablespoons of sugar gradually until you get glossy, soft peaks, about 4 minutes. Take care not to over-whip the whites—they shouldn't be stiff.

5. Strain the raisins over a small bowl, reserving the rum. Add the raisins, tangerine zest, and 1 tablespoon of the reserved rum to the yolk and cream mixture and stir to combine. Fold in the egg whites in three additions, until incorporated.

6. Transfer the mixture to the lined bowl and smooth the top. Fold the plastic wrap up and over to cover, then wrap with foil and freeze overnight.

7. Make the brittle: Line a small (9x13-inch or 30x20-cm) baking sheet with parchment paper. Heat a medium saucepan over medium-high heat, then add the sugar in a single layer and gently melt, swirling the pan regularly, until amber in color, about 4 minutes. Add the hazelnuts, stirring with a spatula until they are well coated, then immediately remove from the heat. Pour the mixture onto the prepared sheet and spread out as much as possible. Sprinkle with a little flaky salt and set aside to cool and set. Once set, roughly chop into ¾-inch (2-cm) pieces and set aside, covered.

8. Make the tangerine caramel: Heat a medium saucepan over medium-high heat, then add the sugar in a single layer and gently melt, swirling the pan regularly, until amber in color, about 4 minutes. Reduce the heat to medium, pour in the tangerine juice (it will bubble vigorously at first), and stir until the caramel melts and is smooth again, 1 to 2 minutes. Continue to stir for 3 to 4 minutes more, until you get the consistency of a slightly thicker maple syrup. Stir in the vanilla bean paste and set aside to cool.

9. Assemble the dessert: Once the tangerine caramel has cooled, remove the semifreddo from the freezer and leave to stand for a few minutes before removing the foil and peeling back the plastic wrap. Place a large plate with a lip over the pudding bowl and quickly flip the whole thing over. Remove the pudding bowl to release the semifreddo, then carefully peel away the plastic wrap.

10. Add 1 tablespoon of the reserved rum to the caramel and whisk until smooth and loosened. Pour the caramel over the semifreddo, letting it drip attractively around the edges.

11. Top the semifreddo with the hazelnut brittle, creating height for dramatic effect, and serve at once.

CRANBERRY-THYME SHORTBREAD

BY ERIN GLEESON

Makes 16 squares

* ⅔ cup (130 g) sugar
* 2 cup (250 g) all-purpose flour
* 2 sticks (8 oz or 230 g) salted butter, cold and cut into chunks
* 1 teaspoon fresh thyme leaves
* ½ cup dried cranberries

1. Pulse everything in a food processor—briefly!—just until combined. It will be crumbly.

2. Press the mixture into a square 8×8-inch (20×20-cm) baking dish.

3. Bake at 325°F (165°C) for 30 minutes, or until a bit golden on the edges. Cool for 5 to 10 minutes before cutting into 1-inch (2.5-cm) squares.

Still Life with Cake (detail)
1818, Raphaelle Peale

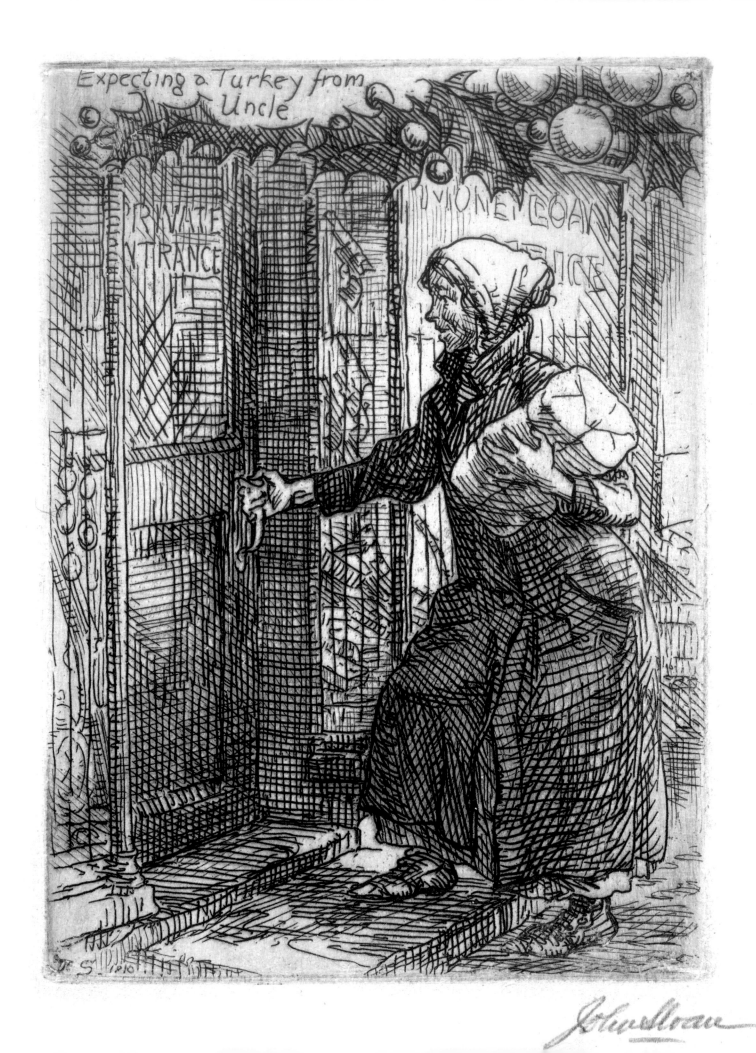

Turkey Pot Pie

By Fred Sabo, Executive Chef at The Dining Room, The Metropolitan Museum of Art

Makes 10 portions

- One 8-pound (3.6 kg) whole turkey
- 3 to 4 bay leaves
- ¾ cup (9 oz) canola oil
- 2 large onions, diced
- 2 large carrots, peeled and diced
- 8 cloves garlic, finely minced
- One bouquet garni (sachet of fresh thyme, rosemary, bay leaf, black peppercorns)
- 1 cup (240 g) heavy cream
- ¾ cup (102 g) pastry flour
- 1 10×15-inch (25×38-cm) sheet puff pastry, ⅛ an inch (.32 cm) thick
- 1 cup (220 g) English peas, fresh or frozen
- Salt and ground pepper
- Dash of Worcestershire sauce
- Dash of soy sauce
- 1 egg

1. Preheat oven to 350°F (176°C). Season and roast your turkey as you would for Thanksgiving, but do not stuff the turkey. When done roasting, let it cool down completely. Save the drippings in the roasting pan.

2. Pull off the turkey's skin and discard. Pull all the meat away from the bones in large pieces and cut those pieces into 1-inch cubes. Set the meat aside.

3. Place the bones along with any roast drippings into a tall stock pot. Cover the bones with water and bring to a slow simmer. Add a few bay leaves and let cook 3 to 4 hours. Skim off any fat that rises to the top, then strain and discard the bones.

4. While making the stock, prepare the sauce. Bring a heavy-bottomed stock pot to low heat and add the oil. Add the onions, carrots, and garlic and sauté slowly for 5 minutes. Add the flour and stir well for 3 minutes on very low heat; do not let the mixture burn or get dark. Pour the turkey stock into this pot and turn the heat back to a slow simmer. Stir well to dissolve any lumps. Add the bouquet garni and let cook for 30 minutes until thick. Remove the bouquet garni and add the heavy cream and turkey meat. Mix well and let cool. Note that this turkey mixture can be made a day or two ahead of when you plan to serve (refrigerate until use).

5. To make the pot pies, place the cold turkey mixture in 10 heavy, single-serve casserole dishes no larger than 5 inches (13 cm) in diameter. Add about 6 to 8 ounces (170 to 227 g) of mixture and a tablespoon of peas to each dish.

6. Remove the puff pastry from the freezer and place it on a lightly floured cutting board to thaw for 5 to 10 minutes. Cut out circles 8 inches (20 cm) in diameter so that the pastry will hang over the sides of the casserole dishes.

7. Whip the egg and use a small brush to paint the rim of each casserole dish with egg. Center and place the pastry circles over the tops of the casserole dishes and crimp the edges with your fingertips to pressing the pastry onto the dish. Add a little cream to the leftover egg and brush the pastry tops with the mixture. Place the covered pies back in the fridge to set.

8. Preheat oven to 350°F (176°C). Bake the pies for 30 to 40 minutes until tops are puffed and golden brown.

Turkey from Uncle
1910, John Sloan

Beef Shepherd's Pie

by Fred Sabo

Executive Chef at The Dining Room, The Metropolitan Museum of Art

Makes 4 portions

- ½ cup (6 oz) canola oil
- 6 cloves garlic, minced
- 2 onions, diced small
- 1 teaspoon oregano
- 16-ounce (500 g) can plum tomato puree
- Salt and black pepper
- 1 large egg yolk
- 1 large carrot, diced small
- 4 ribs celery, diced small
- 1 pound (453 g) ground beef
- 1 cup (227 g) chicken bouillon
- ½ tsp thyme
- ½ tsp marjoram
- ½ tsp nutmeg
- 4 large potatoes, peeled
- ½ cup (60 g) cream
- ½ cup (113 g) butter

1. In a heavy skillet over medium heat, add half the oil plus the garlic and onions. Sweat the vegetables until soft and translucent, then add dried herbs, cooking for 3 more minutes. Add tomato puree and simmer for 20 minutes.

2. While this is cooking, in another heavy-bottomed skillet, add the remaining oil and turn up the heat. When the oil starts to smoke just a little, add the ground beef and sauté until cooked thoroughly, about 7 to 10 minutes. Turn off heat and drain off excess fat. Add the meat to the tomato sauce and cook the beef mixture on a low simmer for 30 minutes until it is semi-dry. Season with salt and pepper and allow the mixture to cool.

3. Place the potatoes in a large pot and cover with water. Bring to a boil and cook about 30 minutes. In the mean-time, heat up the cream in another small pot. When the potatoes are done cooking, drain and mash them in a large bowl with the warm cream, plus butter and egg yolk.

4. Pour the meat mixture into a deep casserole dish, about 9×13 inches (23×33 cm). Spread the potato mixture over the top starting at the edges, creating a 1½-inch (3.8-cm) layer of potato to completely cover the meat. Place in a preheated 350°F (176°C) oven for 25 minutes until the potatoes start to brown. Remove from oven and let cool for 10 to 15 minutes before serving.

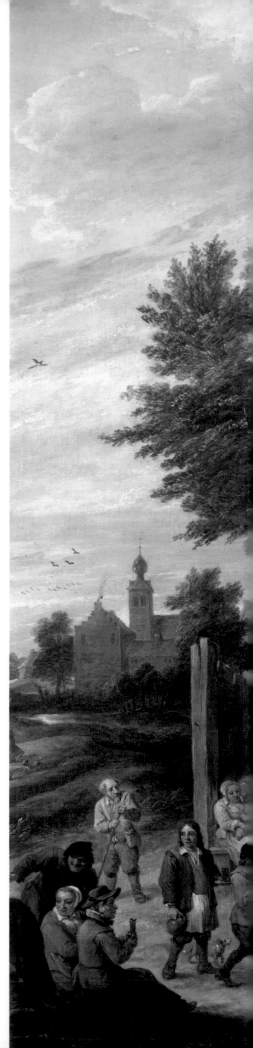

Peasants Dancing and Feasting (detail)
ca. 1660, David Teniers the Younger

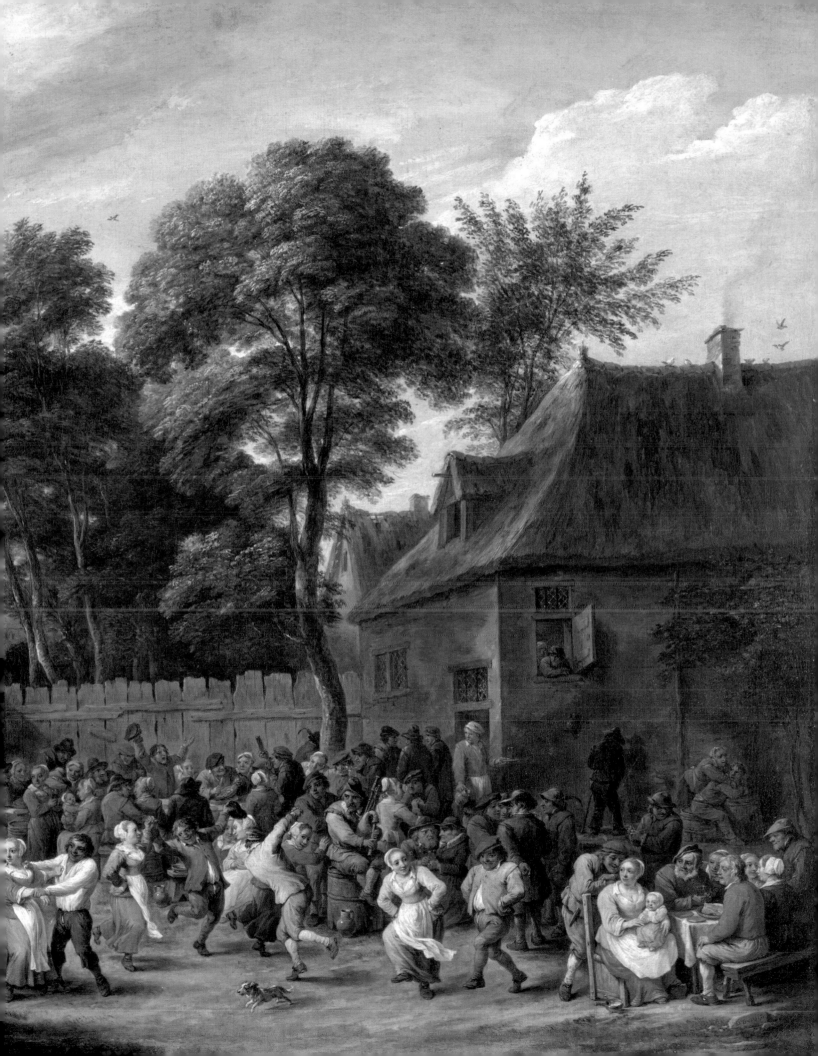

AUTHOR BIOGRAPHIES

Alma Flor Ada (1938–) is the author of numerous books for children and adults. In addition to receiving the Pura Belpré Award, she was honored by the government of Mexico with the Ohtli Award for services to Mexican communities in the United States. She lives in California.

Frances Pharcellus Church (1839–1906) was an editor and publisher from New York. He founded the *Army and Navy Journal* and *Galaxy* magazine with his brother. He also was a writer for his brother's newspaper, the *New York Sun*, where he wrote his famous essay "Yes, Virginia, there is a Santa Claus" in 1897.

e. e. cummings (1894–1962) was a prolific poet known for experimenting with traditional poetic form, structure, and punctuation. In his lifetime, he volunteered as an ambulance driver during WWI, met with artists including Pablo Picasso, and won a variety of honors, including the Academy of American Poets Fellowship.

Sir Arthur Conan Doyle (1859–1930) was the creator of Sherlock Holmes, the famous detective featured in more than fifty stories. Prior to writing full-time, Conan Doyle worked as a doctor. He was knighted by King Edward VII for his services during the Boer War.

Paul Laurence Dunbar (1872–1906) was one of the first influential African American poets. He gained national acclaim in 1895, when his poetry was featured in the *New York Times* and other newspapers. Throughout his lifetime, he published numerous collections of poetry and several novels.

Mary E. Wilkins Freeman (1852–1930) was a popular writer of short stories, novels, and poetry. Her work focused on women in rural New England, especially those in the lower and working class. She was awarded the William Dean Howells Gold Medal for Fiction in 1926.

Nikki Giovanni (1943–) has published children's books and more than ten collections of poetry. In addition to more than twenty honorary degrees, she has received the Langston Hughes Award for distinguished contributions to arts and letters, the NAACP Image Award for literature, and the Rosa L. Parks Woman of Courage Award. She serves as University Distinguished Professor at Virginia Tech.

Jacob (1785–1863) and Wilhelm (1786–1859) Grimm were German academics and cultural researchers who collected stories and compiled them into several volumes today known generally as *Grimms' Fairy Tales*. Some of the most well-recognized stories include *Hansel and Gretel*, *Little Ride Riding Hood*, and *Snow White*.

Lee Bennett Hopkins (1938–) was inducted into the Florida Artists Hall of Fame in 2017. He holds a *Guinness Book of Records* citation for compiling the most anthologies for children. He has also received the Christopher Award, the Regina Medal, and the National Council for Teachers of English Excellence in Poetry for Children Award. He lives in Florida.

J. Patrick Lewis (1942–) received the National Council of Teachers of English Excellence in Poetry for Children Award. He became the third United States Children's Poet Laureate (2011–13). He lives in Ohio.

H. P. Lovecraft (1890–1937) wrote across various genres, but he is best known for his short stories, which were first published in the horror magazine *Weird Tales* in 1923. A struggling writer, Lovecraft worked as an editor and a ghostwriter, and it was only after his death that his work gained acclaim.

L. M. (Lucy Maud) Montgomery (1874–1942) worked as a teacher before she began writing full-time. She wrote poetry, short stories, and novels that expressed her love of nature and the imagination. Her best-known work, *Anne of Green Gables*, was published in 1908.

Clement Clarke Moore (1779–1863) wrote on a variety of academic subjects, but he is best known for writing the children's poem "'Twas the Night Before Christmas," which he anonymously published in 1823. He taught at the General Theological Seminary in New York City for thirty-one years.

Ogden Nash (1902–1971) published more than twenty collections of humorous poetry and was known for using unconventional rhyme schemes. He also dabbled in writing for the screen and stage; he wrote scripts for MGM Studios and the 1943 Broadway show *One Touch of Venus*.

Naomi Shihab Nye (1952–) is a multi-award-winning poet. Her collection *19 Varieties of Gazelle: Poems of the Middle East* was a finalist for the National Book Award. She lives in Texas.

Christina Rossetti (1830–1894) was a Victorian poet best known for exploring religious and spiritual topics. She had more than nine collections of poetry published, the most popular being *Goblin Market and Other Poems*.

William Shakespeare (1564–1616) was an English poet, playwright, and actor widely regarded as the greatest writer in the English language. He wrote 154 sonnets and more than thirty plays, which are still performed around the world.

Izumi Shikibu (c. 976–c. 1030 ce) was a Japanese poet during the Heian era (794–1185 CE). Her poetry drew on the tradition of courtly love, and her most well-known work is a diary detailing her romances with two princes. Her work has been translated and included in numerous poetry collections.

Marilyn Singer (1948–), a prolific author who writes in a variety of genres, was a recipient of the National Council of Teachers of English Excellence in Poetry for Children Award. She divides her time between New York and Connecticut.

The Night Before Christmas
1931, Arthur Rackham

Robert Louis Stevenson (1850–1894) was a popular Scottish poet and novelist best known for *Treasure Island* and *The Strange Case of Dr. Jekyll and Mr. Hyde*. He traveled extensively before he permanently settled in Upolu, one of the Samoan islands, in 1890.

Eunice Tietjens (1884–1944) was a poet, novelist, and editor most interested in expressing her experiences as a traveler. In her lifetime, she published four collections of poetry, served as a World War I correspondent, and participated in the Chicago literary renaissance.

Leo Tolstoy (1828–1910) was a Russian writer who wrote novels, short stories, essays, and plays. His novels *War and Peace* and *Anna Karenina* are regarded as his greatest works.

Mark Twain (1835–1910), real name Samuel Clemens, was an American writer, humorist, and lecturer. His work depicted American life in the nineteenth century and provided social commentary. Some of his most famous works include *The Adventures of Tom Sawyer*, *A Connecticut Yankee in King Arthur's Court*, and *Adventures of Huckleberry Finn*.

Henry van Dyke (1852–1933) wrote poetry and essays, and his work was published in more than seventy books. In his lifetime, he served as a Presbyterian minister, a professor at Princeton University, and a United States diplomat during World War I.

Janet S. Wong (1962–), a former lawyer, writes picture books and poetry for children, many based on her Asian American experiences. She is a popular speaker at various literary events throughout the country. She lives in New Jersey.

William Wordsworth (1770–1850) was a poet with a deep interest in the life and thoughts of the "common man." With poet Samuel Taylor Coleridge, he published *Lyrical Ballads* in 1795, one of the most influential poems of Western literature. Wordsworth's most famous work, *The Prelude*, was published after his death in 1850.

Artist Biographies

Irving Amen (1918–2011), American, was a New York–based artist who worked in many media. He is perhaps best known for his woodcut prints. Amen was also a teacher of younger artists.

Wilson Alwyn Bentley (1865–1931) lived his entire life on a Vermont farm. By adapting a camera to a microscope, he developed a technique for photographing individual snowflakes before they melted. He captured several thousand examples over his lifetime, no two the same.

Margaret Morton Bibb (c. 1832–c. 1900–1910) and her sister, Ellen Morton Littlejohn (1826–1899), were enslaved African Americans who worked for the Morton family of Kentucky. Their quilt design was based on the eight-pointed "Star of Bethlehem" motif, variations of which have been popular with quiltmakers for generations.

Alden Finney Brooks (1840–1932), American, took up painting after serving with the Union Army during the American Civil War. After the war he studied in New York and Paris and finally opened a studio in Illinois.

The **Jefferson R. Burdick Collection** is a treasure trove of over 300,000 examples of popular printmaking. It includes advertising inserts, trading cards, postcards, greeting cards, posters, and much more. Pieces date from the 1860s through to 1963, the last year of Burdick's life. The Burdick Collection of baseball cards is the largest after that at the Baseball Hall of Fame in Cooperstown, New York.

Luca Cambiaso (1527–1585) was an Italian artist who worked in the Mannerist style. He was an accomplished painter but is best known today for his energetic and inventive drawings. He was strongly influenced by Michelangelo and other Renaissance artists.

Julia Margaret Cameron (1815–1879), a British photographer, was forty-eight years old and a mother of six when she received a camera as a gift and made her very first picture. She used her family and friends as models for images that were often inspired by religious and literary themes.

Federico Cantú (1907–1989) was a Mexican painter, sculptor, and printmaker. He was affiliated with Diego Rivera and other artists of the Mexican muralism movement. However, Cantu's work reflects his interest in classical and religious themes. He traveled widely, exhibiting and accepting commissions in the United States and Europe.

Jean Charlot (1898–1979) was born in France but also had Russian and Mexican lineage. He was a painter, illustrator, and muralist who spent most of his career in Mexico and the United States, where he became a naturalized citizen in 1940. His wide-ranging interests included pre-Colombian languages and archeology.

Alvin Langdon Coburn (1882–1966) was born in Boston. His work traces photography's transition from pictorialism to modernism at the turn of the century. In New York City, he was involved with the artists and intellectuals surrounding Alfred Stieglitz before moving to London around 1912. He became a British citizen in 1932, settling in northern Wales.

Bruce Crane (1857–1937) was an American landscape painter who worked in New York State, New Jersey, and Connecticut. He was influenced by artists of the Barbizon School and French Impressionism, although unlike them, he usually painted indoors from memory.

Charles-François Daubigny (1817–1878) was a French landscape artist. He is associated with the Barbizon School, named for the town at the edge of the Forest of Fontainebleau where they frequently painted. This group of artists broke with tradition by leaving their studios to work outside in nature.

Adolphe de Meyer (1868–1946) was a photographer born in France. Some of his most well-known works are portraits of celebrities and fashion plates. However, his most experimental pictures were still lifes made with innovative use of light and shadow, bordering on the abstract.

Bartolo di Fredi (c. 1330–1410) was an Italian Early Renaissance painter. He lived and worked in Siena and its surrounding towns, receiving numerous commissions for paintings to decorate churches and government buildings.

Josef Diveky (1887–1951), Hungarian. See **Wiener Werkstätte**.

Utagawa Hiroshige (1797–1858), born in Tokyo, lived and worked during the Edo period. His beautifully colored woodblock prints are among the finest examples of Japanese landscape images. His compositions continue to influence Eastern and Western artists alike.

Wenceslaus Hollar (1607–1677) was born in Prague but spent much of his career in England. He is best known as a printmaker, having produced several thousand etchings. His cityscapes of London date from both before and after the devastation of the 1666 Great Fire of London.

Winslow Homer (1836–1910), American, was a master of both oil and watercolor painting. His subjects ranged from returning Civil War soldiers and emancipated slaves to more lighthearted topics. Some of his scenes of leisure and recreation, reproduced as prints by the firm of Currier and Ives, reached a wide public.

Mela Koehler (1885–1960), Austrian. See **Wiener Werkstätte**.

Carl Krenek (1880–1948), Austrian. See **Wiener Werkstätte**.

Jacob Lawrence (1917–2000), born in New Jersey, spent most of his career in New York. He is most well-known for his depictions of significant moments in Black history, such as his *Migration Series*, which tells of the movement of millions of African Americans from the rural South to the industrial North.

Sergei Lednev-Shchukin (1875–1961) was a Russian painter who lived and worked most of his life in Moscow. His landscapes and scenes of small villages show the influence of the French Impressionists.

Ellen Morton Littlejohn (1826–1899) and her sister, Margaret Morton Bibb (c. 1832–c. 1900–1910), were enslaved African Americans who worked for the Morton family of Kentucky. Their quilt design was based on the eight-pointed "Star of Bethlehem" motif, variations of which have been popular with quiltmakers for generations.

Louis Maurer (1832–1932), German, for Currier and Ives; Currier and Ives, in business from 1835 to 1907, was a New York City publisher of inexpensive lithographic prints. They worked with famous artists, as well as many who were little-known. Their inexpensive process meant that decorative works of art were affordable and available to ordinary Americans. Over the life of the business, more than a million prints were sold. Subjects included news events, political satire, family scenes, leisure activities, railroads, ships, hunting, fishing, and much more.

William Sidney Mount (1807–1868) was born in Setauket, New York. He is best known for his paintings of rural American life, made at a time when the United States was fast becoming a more modern, urban society. His work captures life unaffected by growing industry and the expansion of the railroads.

Raphaelle Peale (1774–1825) was an American portraitist and still life painter. His tightly grouped still lifes are often permeated with a delicate melancholy. His spare, essential style may have been influenced by the Spanish still lifes he studied in Mexico.

Edward Penfield (1866–1925), American, was one of the most successful poster and magazine illustrators of his time. His style, combining strong shapes, bold outlines, and only the most essential details of a scene, was ideal for capturing a viewer's attention from a distance.

Camille Pissarro (1830–1903) was born in the West Indies to French parents. He sometimes exhibited with the group of artists called Impressionists. Like some of them, he would paint the same scene many times, capturing subtle differences in the light and the effects of weather.

Arthur Rackham (1867–1939) was a British illustrator, most well-known for his work in children's books. His great success was due both to his imaginative depictions of amusing and frightening creatures and to the advancement of an early mechanized color-printing process.

Abraham Rademaker (1677–1735), born in Lisse in the Netherlands, was a draughtsman, painter, and printmaker. His renderings of buildings and towns provide a window into ordinary life of the period.

Louis John Rhead (1857–1926) was born in England to a family that had worked in the Staffordshire Potteries for generations. He emigrated to the United States in his twenties, where he became successful with graphic art. He is known for posters, magazine covers, and book illustrations.

Severin Roesen (1816–1972), born in Germany, emigrated to the United States in 1848. His meticulously detailed paintings of flower and fruit arrangements are strongly reminiscent of seventeenth-century Dutch still lifes.

August Salzmann (1824–1872) was a French photographer and archaeologist. He journeyed from Paris to Jerusalem in 1853 with a desire to prove the literal truth of biblical stories through objective photography of sites in and around Jerusalem. While he aimed for scientific accuracy, Salzmann's photographs are also evocative and inspiring.

Sassetta (c. 1400–1450) is the name commonly used for Stefano di Giovanni, an Italian Renaissance painter. He is known as a master of the Sienese style, which combines an otherworldly sweetness with charming contemporary details.

James Jebusa Shannon (1862–1923), born in New York, spent most of his career in England. He became one of the leading portrait painters in London. Close to the end of his life, he renounced his American citizenship in order to accept a knighthood.

Merry Christmas Eve! (Fröhliche Christnacht!)
1908, Josef Diveky

Alfred Sisley (1839–1899), born to English parents, lived his entire life in France. He was a landscape painter affiliated with the group of artists dubbed Impressionists. Like them, he painted outdoors, where he strove to capture the effects of changing light.

John Sloan (1871–1951), an American painter and etcher, is one of the founders of the Ashcan School of American art. He is best known for his urban genre scenes and skill in expressing the spirit of neighborhood life in New York City.

Saul Steinberg (1914–1999) was born in Romania but emigrated in 1941 due to rising fascism. He is most well-known for his numerous covers and cartoons published in *The New Yorker*. However, he was also an accomplished painter, sculptor, printmaker, and theater designer.

Henry Ossawa Tanner (1859–1937), born in Pennsylvania, was the son of a mother who escaped slavery and a father who was a bishop of the African Methodist Episcopal Church. He painted biblical stories with universal themes that resonated with the struggles of his era.

David Teniers the Younger (1610–1690), a Flemish painter, printmaker, draughtsman, miniaturist painter, and copyist, was known for a number of genres including landscape, genre, portrait, still life, and landscape. He was a leading Flemish genre painter, developing the peasant genre, the tavern scene, pictures of collections, and scenes with alchemists and physicians.

Austin Augustus Turner (c. 1813–1866), American, produced daguerreotypes as well as other early forms of photography. He worked and lived in numerous locations from Maine to Louisiana, including a brief spell in New York when he worked in the studio of the acclaimed Mathew Brady.

Unknown, Ethiopia: The style called First Gondärine flourished in the seventeenth and eighteenth centuries when there was significant trade and exchange of ideas between Europe and Africa. These depictions of New Testament figures— with thick outlines surrounding flat, bold colors—are typical of the style.

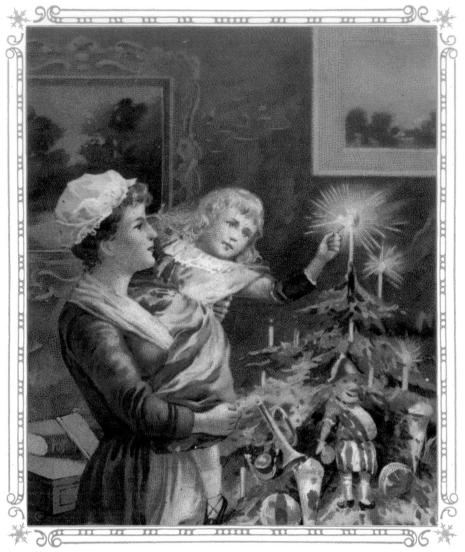

Woman and child with Christmas tree, bakery card from the Picture Cards series (D63), issued by The Heissler & Junge Company
Early twentieth century

Wiener Werkstätte, which translates as "Viennese Workshop," refers to a group of artists and artisans who worked together at the beginning of the twentieth century. Their mission was to bring their modern aesthetic and design principles to all aspects of life. They produced books, furniture, fashion, home goods, and many other objects.

Thomas Waterman Wood (1823–1903), born in Vermont, was a descendant of New England Puritans. He is best known for paintings that depict African Americans at the time of the Civil War and in emancipation from slavery.

Fritz Zeymer (1886–1940), Austrian. See **Wiener Werkstätte**.

Xie Zhiliu (1910–1997), Chinese, was trained in the classical tradition of calligraphic painting. Like earlier practitioners, Xie pared down the elements of nature to beautiful, stylized lines. However, in his work, the careful observation of the natural world is always evident.

Ugo Zovetti (1879–1974). See **Wiener Werkstätte**.

Page i
Holiday ribbon featuring scene of snowman,
1960–82
Attributed to Warner Woven Label Co.
(American)
Silk, woven
Gift of Rebecca Tribull Weber, 2014
2014.594.4

Pages ii–iii
*Christmas Card Depicting Hanging Holly by
Candlelight*, ca. 1920s
Anonymous
Commercial process
Gift of Diane Carol Brandt, 2013
2013.521.1

Page iv
Deer in the Woods, 1850
Charles-François Daubigny (French)
Etching; third state of three
Gift of Theodore De Witt, 1923
23.65.67

THE FIRST CHRISTMAS
Pages vi–vii
Two Angels, first quarter fourteenth century
North Italian Painter
Fresco
Bequest of Edward Fowles, 1971
1971.115.1ab

Page viii
Double Diptych Icon Pendant, early
eighteenth century
(Ethiopian)
Wood, tempera pigment, string
Rogers Fund, 1997
1997.81.1

Page 3
The Adoration of the Shepherds, 1374
Bartolo di Fredi (Italian)
Tempera on poplar, gilding
The Cloisters Collection, 1925
25.120.288

Page 4
The Journey of the Magi, ca. 1433–35
Sassetta (Stefano di Giovanni) (Italian)
Tempera and gold on wood
Maitland F. Griggs Collection, Bequest of
Maitland F. Griggs, 1943
43.98.1

Page 7
Flight Into Egypt, 1923
Henry Ossawa Tanner (American)
Oil on canvas
Marguerite and Frank A. Cosgrove Jr. Fund,
2001
2001.402a

STORIES AND TALES
Pages 8–9
*A Russian Church in Snow with a Man Riding
a Sleigh*, twentieth century
Sergei Lednev-Shchukin (Russian)
Gouache, watercolor, over black chalk
Bequest of Mary Jane Dastich, in memory of
her husband, General Frank Dastich, 1975
1975.280.12

Page 10
Rue Eugène Moussoir at Moret: Winter, 1891
Alfred Sisley
Oil on canvas
Bequest of Ralph Friedman, 1992
1992.366

Page 11
Shoes, 1840–49
(American)
Leather
Brooklyn Museum Costume Collection at
The Metropolitan Museum of Art, Gift of the
Brooklyn Museum, 2009; Gift of The Jason
and Peggy Westerfield Collection, 1969
2009.300.3340a, b

Page 13
La Madonna Riposata, 1865
Julia Margaret Cameron (British; born India)
Albumen silver print from glass negative
Harris Brisbane Dick Fund, 1941
41.21.2

Page 14
Child with Christmas Card, n.d.
Alden Finney Brooks (American)
Watercolor, graphite, and gold paint on wove
cardboard
Maria DeWitt Jesup Fund, 1989
1989.299

Page 16
The Jefferson R. Burdick Collection,
Gift of Jefferson R. Burdick

Page 18
St. Paul's from the Ludgate Circus, 1909
Alvin Langdon Coburn (British)
Photogravure
Gilman Collection, Purchase, Joyce F.
Menschel Photography Library Fund, 2005
2005.100.990.20

Page 21
Tureen in the form of a goose, ca. 1770
(Chinese)
Hard-paste porcelain
Gift of Mrs. Douglas Dillon, 2014
2014.436a, b

Page 23
The Raffle (Raffling for the Goose), 1837
William Sidney Mount (American)
Oil on mahogany
Gift of John D. Crimmins, 1897
97.36

Page 24
*Cries of London, No. 2: Buy my Goose, my fat
Goose*, January 1, 1799
Henri Merke (Swiss)
Hand-colored etching and aquatint
The Elisha Whittelsey Collection, The Elisha
Whittelsey Fund, 1959
59.533.582

Page 26
Goose Hiding its Head, 1895–97
Alfred Sisley (British)
graphite and colored crayon on buff wove
paper, darkened
Robert Lehman Collection, 1975
1975.1.727

Page 27
Two Geese Walking, 1895–97
Alfred Sisley (British)
graphite and colored crayon on buff wove
paper, darkened
Robert Lehman Collection, 1975
1975.1.727

Page 29
Tureen in the form of a goose (one of a pair),
1750
(German)
Faience (tin-glazed earthenware)
The Lesley and Emma Sheafer Collection,
Bequest of Emma A. Sheafer, 1973
1974.356.239a, b

Page 30
The Shoemaker, 1945
Jacob Lawrence (American)
Watercolor and gouache on paper
George A. Hearn Fund, 1946
46.73.2
© 2018 The Jacob and Gwendolyn Knight
Lawrence Foundation, Seattle / Artists
Rights Society (ARS), New York

Page 32
Ring in the Glad New Year, from the New
Years 1890 series (N227) issued by Kinney
Bros., 1889–90
Commercial color lithograph

Page 33
The Jefferson R. Burdick Collection,
Gift of Jefferson R. Burdick

Page 34
The Jefferson R. Burdick Collection,
Gift of Jefferson R. Burdick

Page 123
"Christmas in Summer" copyright
© 2019 Alma Flor Ada

Page 125
Santa Looking at Bird in a Tree, ca. 1952
Saul Steinberg (American)
Ink and colored crayons on paper
Bequest of William S. Lieberman, 2005
2007.49.90
© The Saul Steinberg Foundation/
Artists Rights Society (ARS), New York

Page 126
Asukayama in Evening Snow, ca. 1838
Utagawa Hiroshige (Japanese)
Polychrome woodblock print; ink and color
on paper
The Howard Mansfield Collection, Purchase,
Rogers Fund, 1936
JP2479

Page 128
"Are You Ready for Christmas?"
copyright © 2019 Naomi Shihab Nye

Page 129
Jérusalem, Beit-Lehem, Vue générale, 1854
Auguste Salzmann (French)
Salted paper print from paper negative
Gilman Collection, Gift of The Howard Gilman
Foundation, 2005
2005.100.373.125

Page 130
Quilt, Star of Bethlehem pattern variation,
ca. 1837–50
Ellen Morton Littlejohn and Margaret Morton
Bibb (American)
Silk and cotton
Gift of Roger Morton and Dr. Paul C. Morton,
1962
62.144

Page 131
"Christmas Laughter"
copyright © Nikki Giovanni

Page 132
"Christmas Cherries" copyright
© 2019 Janet Wong

Page 133
[Grove of Cherry Trees], 1900
Adolf de Meyer (American; born France)
Gelatin silver print
Gift of Lunn Gallery, 1980
1980.1128.5

RECIPES
Pages 134–135
A christmas card showing Santa Claus in Paris, 1932
Jean Charlot (French)
Linocut printed in black with stencil coloring
in on Japan paper on red board mounted in a
green paper folder
Gift of Jean Charlot, 1984
1984.1182.2
© 2018 The Jean Charlot Estate LLC/
Member, Artists Rights Society
(ARS), NY. With permission.

Page 136
Still Life with Pears, 1950s
Armand Sinko (French)
Oil on canvas
Robert Lehman Collection, 1975
1975.1.2190

Page 137
No-Bake Goat Cheese Cheesecake with
Gingered Pears
© 2019 Yvette van Boven

Pages 138, 141
Still Life: Fruit, 1855
Severin Roesen (American)
Oil on canvas
Rogers Fund, 1963
63.99

Page 139
Rum Raisin Semifreddo with Tangerine
Caramel and Hazelnut Brittle
© 2019 Yotam Ottolenghi

Pages 142–143
Still Life with Cake, 1818
Raphaelle Peale (American)
Oil on wood
Maria DeWitt Jesup Fund, 1959
59.166

Page 143
Cranberry-Thyme Shortbread
© 2019 The Forest Feast LLC

Page 144
English Toffee
© 2019 Randy Eastman

Pages 144–145
Theatrical Pleasures, Plate 5: Feasting in the Saloon, ca. 1835
Theodore Lane (British)
Hand-colored etching
Harris Brisbane Dick Fund, 1917
17.3.888–328

Page 146
Turkey from Uncle, 1910
John Sloan (American)
Etching
Gift of Mrs. Harry Payne Whitney, 1926
26.30.30
© 2019 Artists Rights Society
(ARS), New York

Page 147
Turkey Pot Pie
© 2019 Fred Sabo

Page 148
Beef Shepherd's Pie
© 2019 Fred Sabo

Page 149
Peasants Dancing and Feasting, ca. 1660
David Teniers the Younger (Flemish)
Oil on canvas
Purchase, 1871
71.99

Page 151
The Night Before Christmas, 1931
Arthur Rackham (British)
Illustrations: photomechanical process
Gift of Mrs. John Barry Ryan, transferred from
the Library, 1983
1983.1223.9

Page 153
Merry Christmas Eve! (Fröhliche Christnacht!), 1908
Josef Diveky (Hungarian)
Color lithograph
Museum Accession, transferred from the
Library
WW. 180

Page 154
Woman and child with Christmas tree,
bakery card from the Picture Cards series
(D63), issued by The Heissler & Junge
Company, early twentieth century
Commercial color lithograph
The Jefferson R. Burdick Collection, Gift of
Jefferson R. Burdick
63.350.307.63.23